Harry Potter™

COLORING WIZARDRY

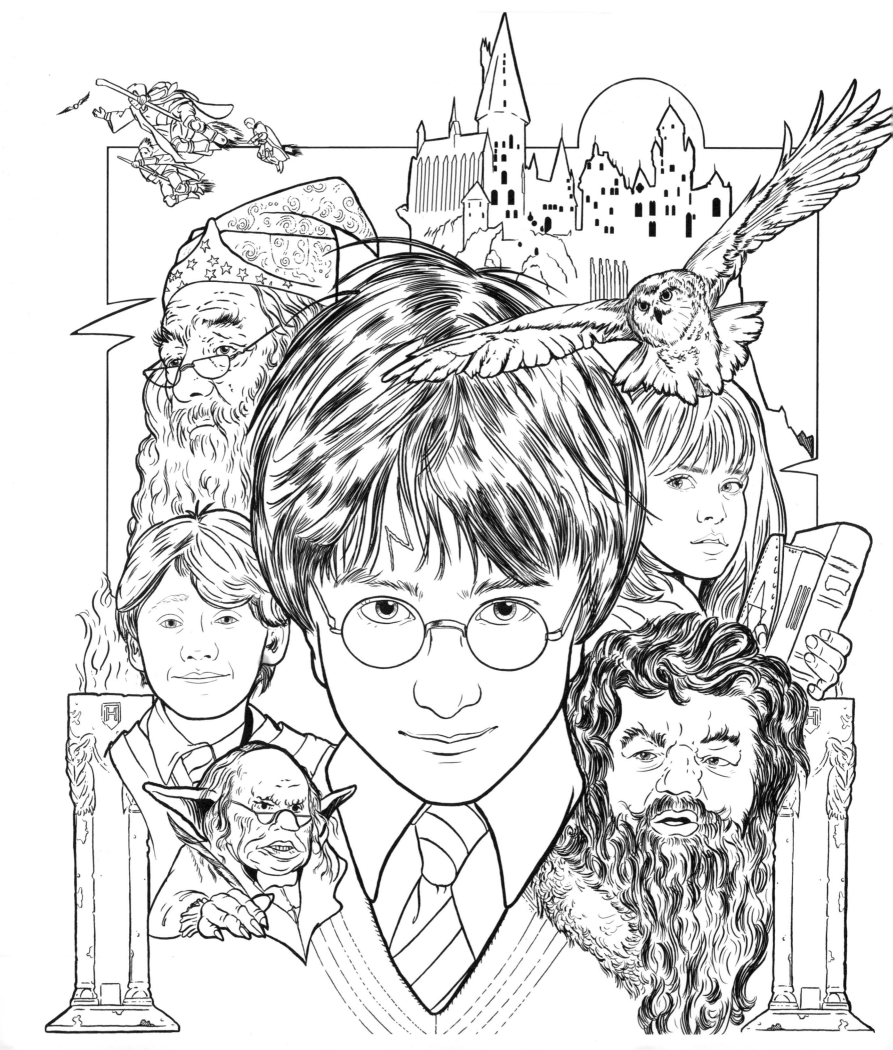

Harry Potter

COLORING WIZARDRY

INSIGHT
EDITIONS

SAN RAFAEL · LOS ANGELES · LONDON

THIS BOOK BELONGS TO

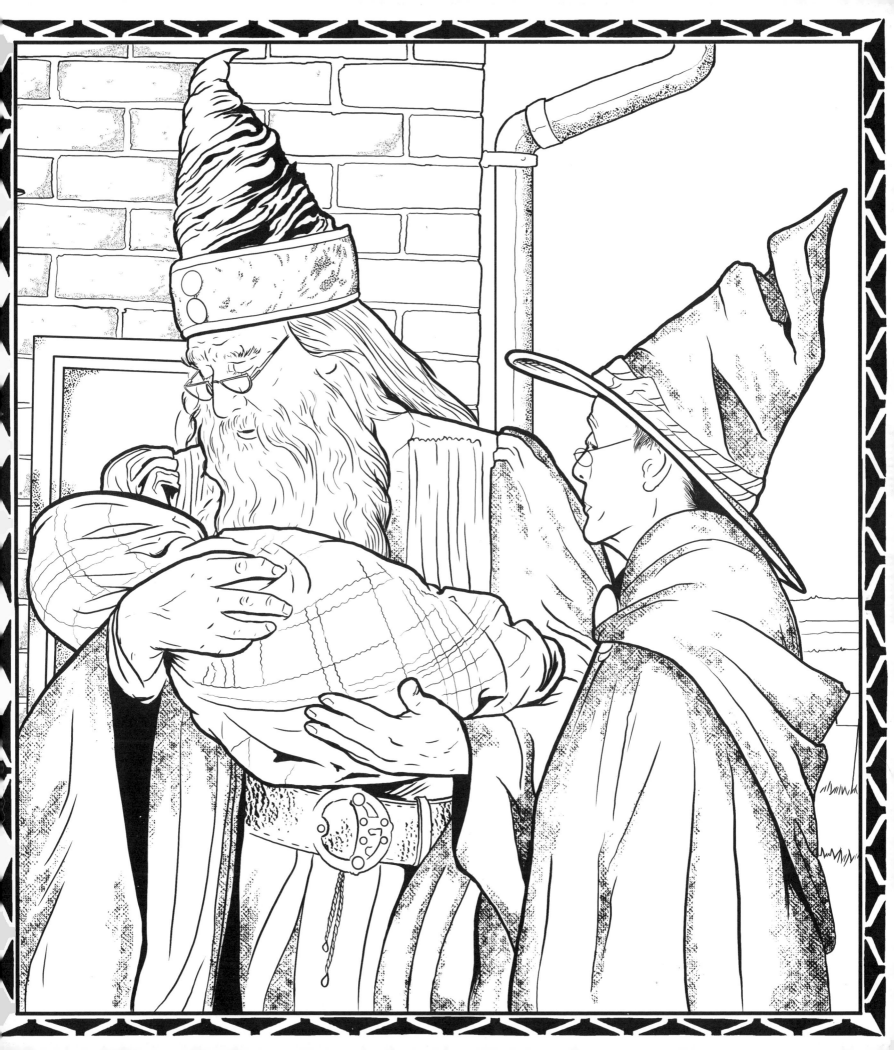

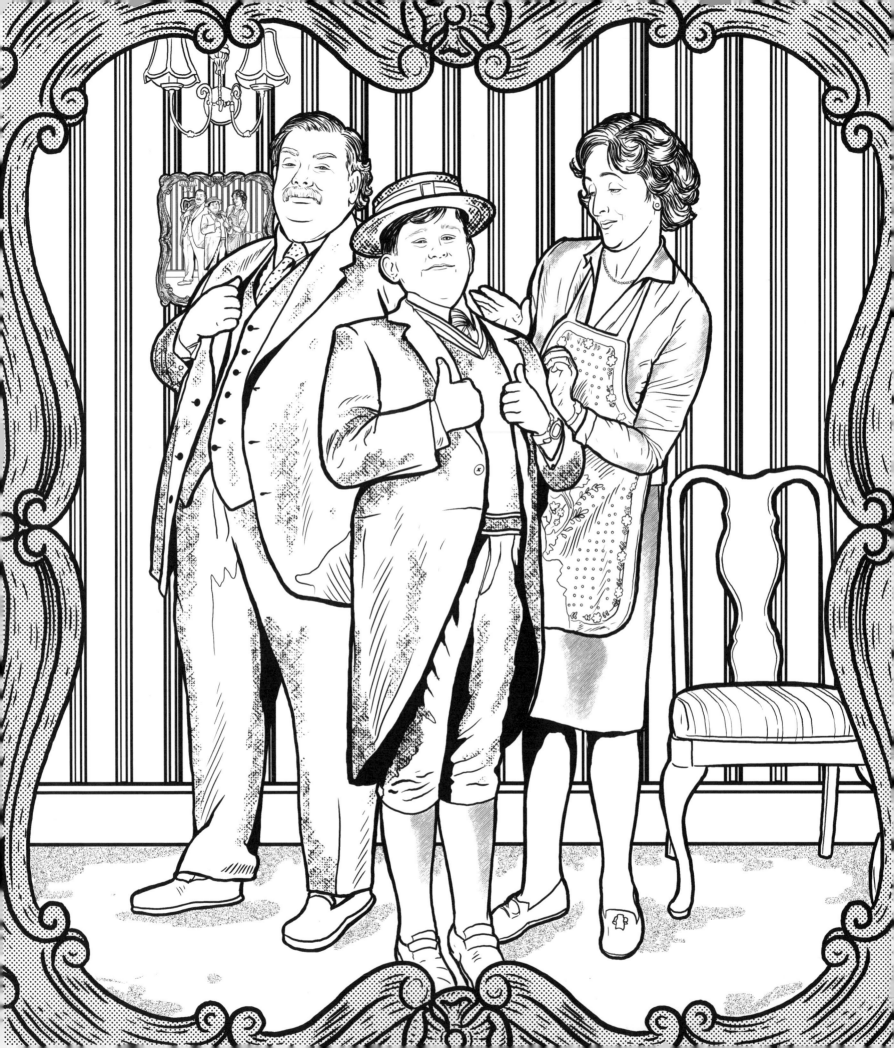

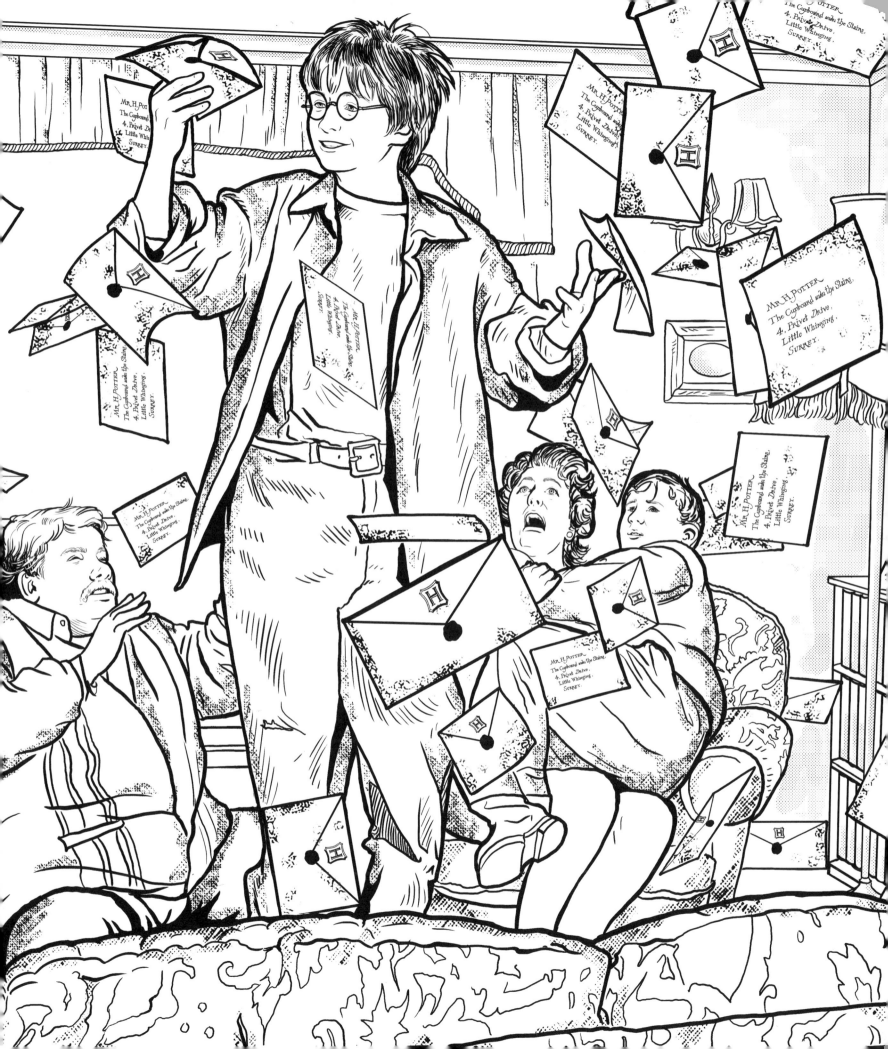

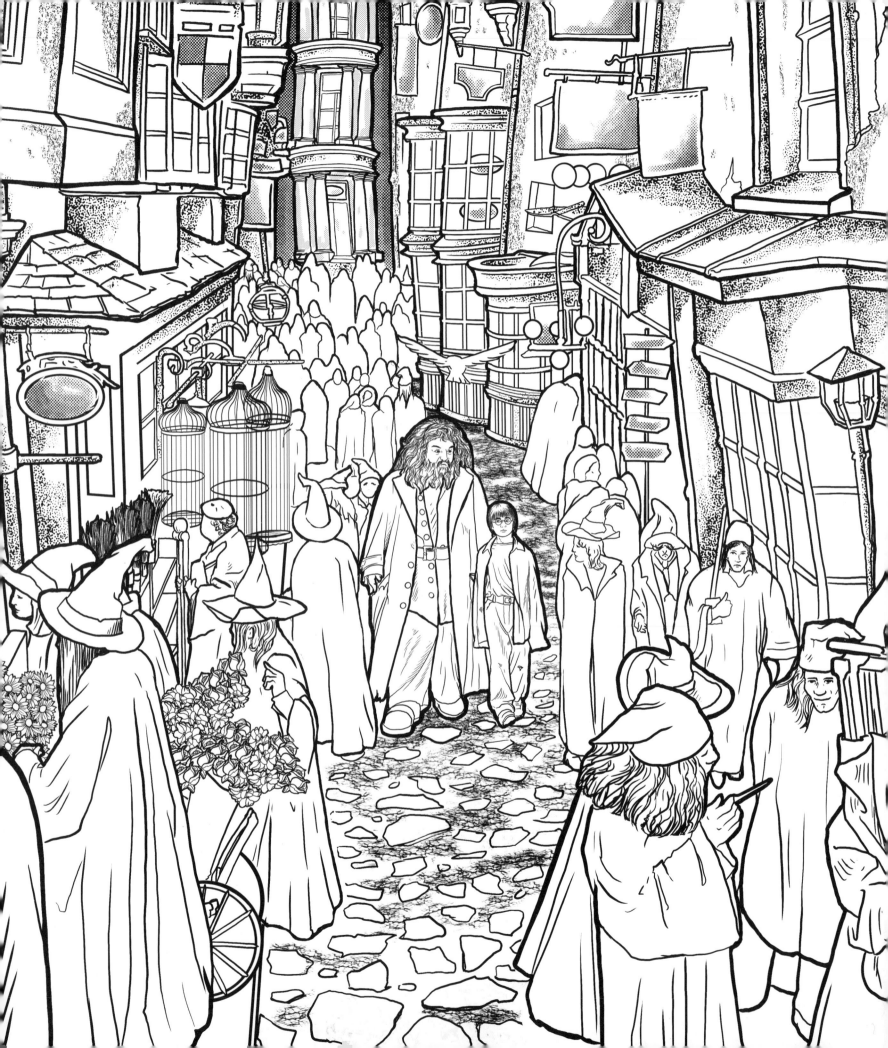

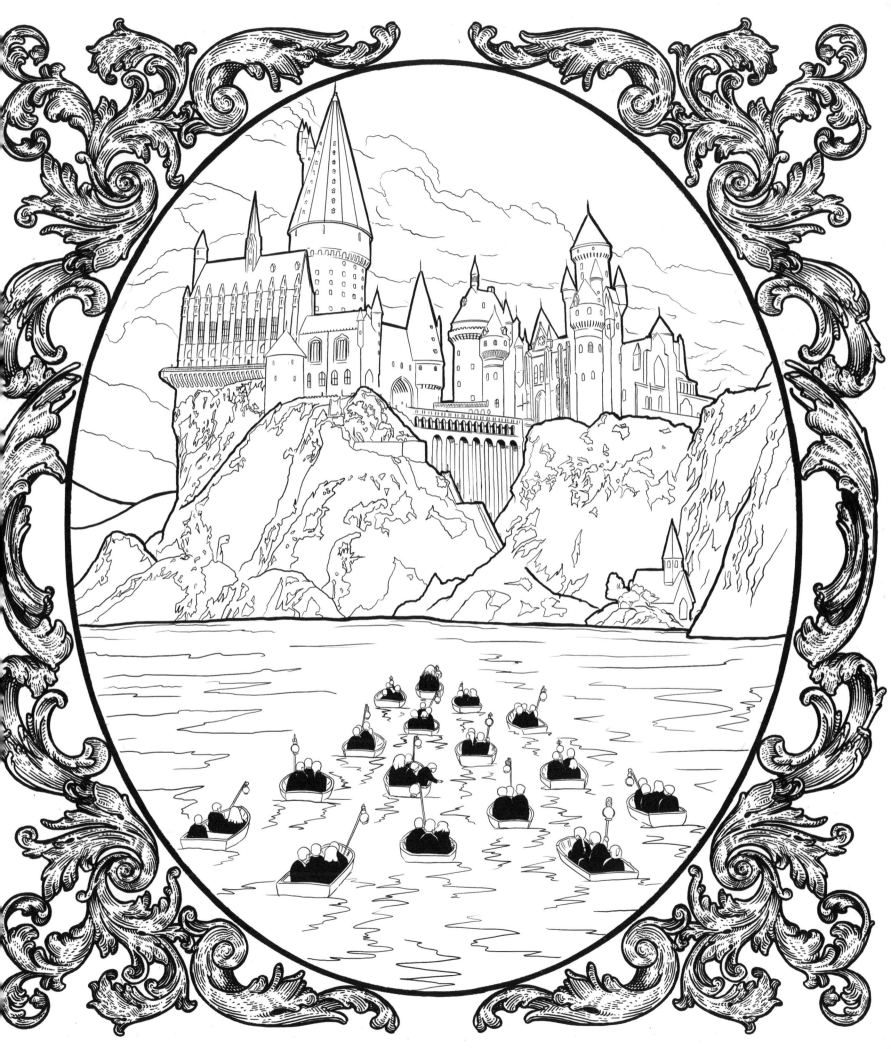

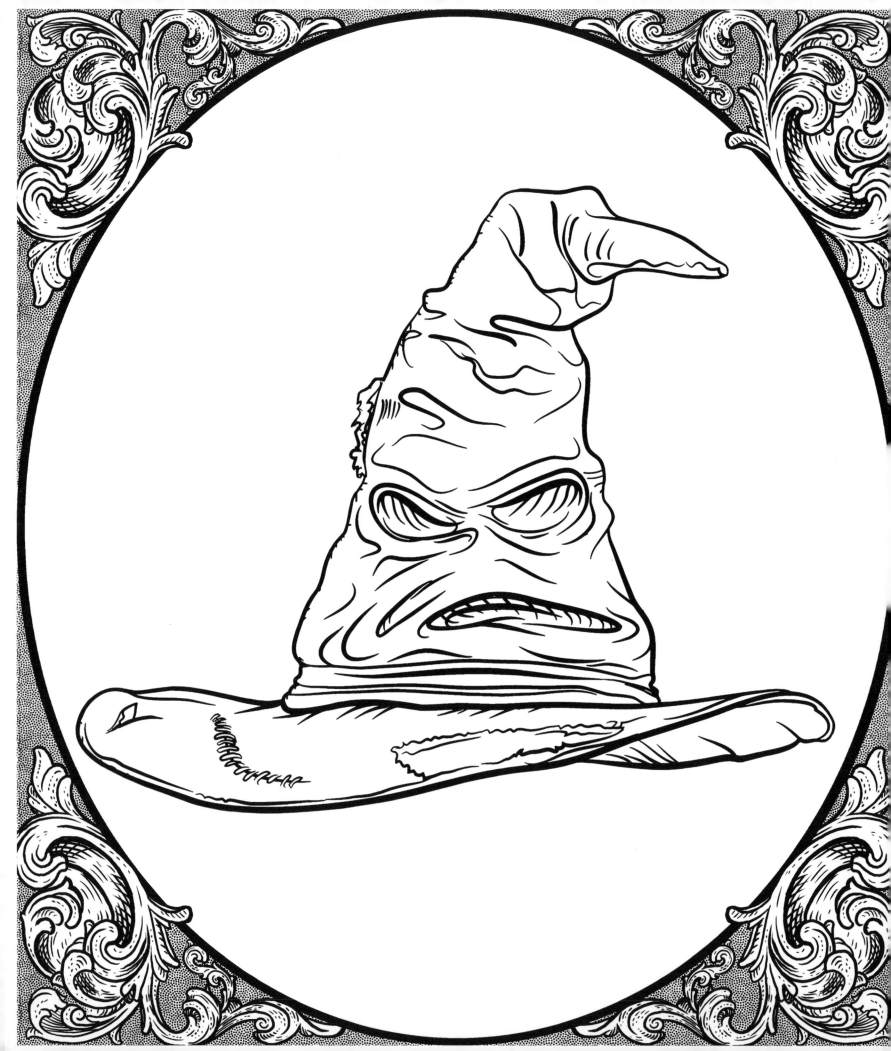

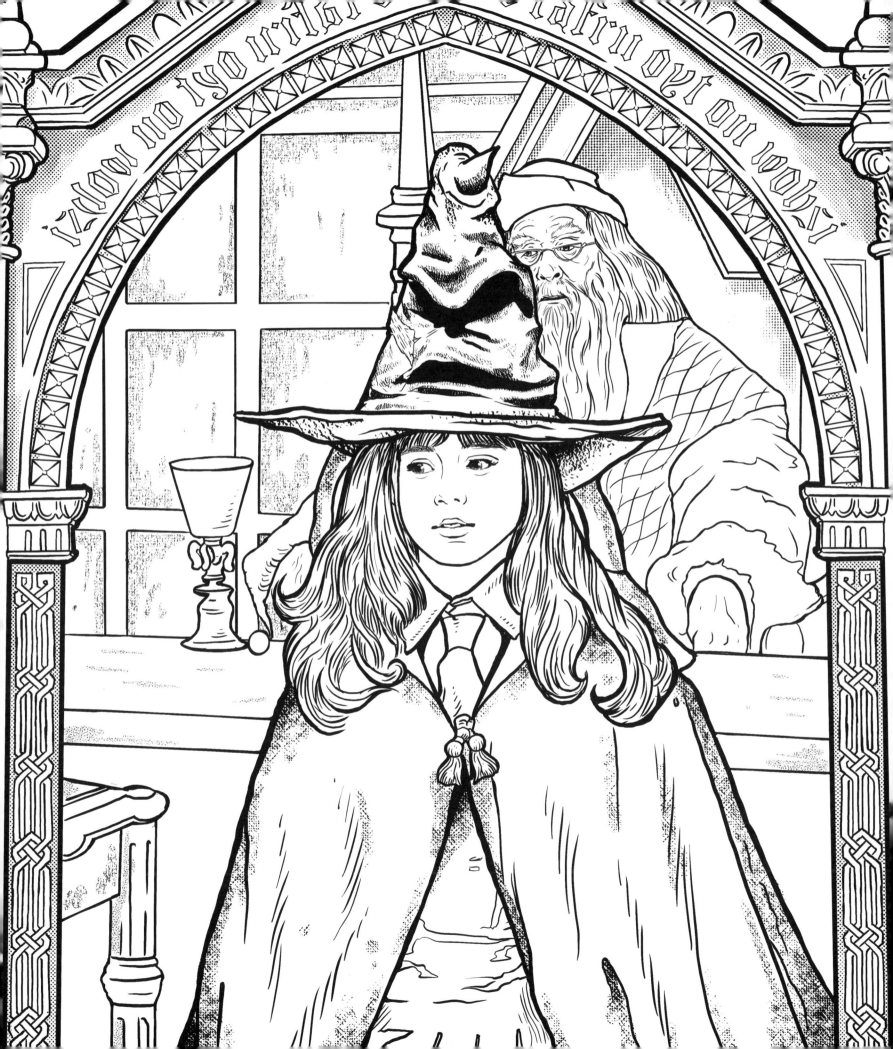

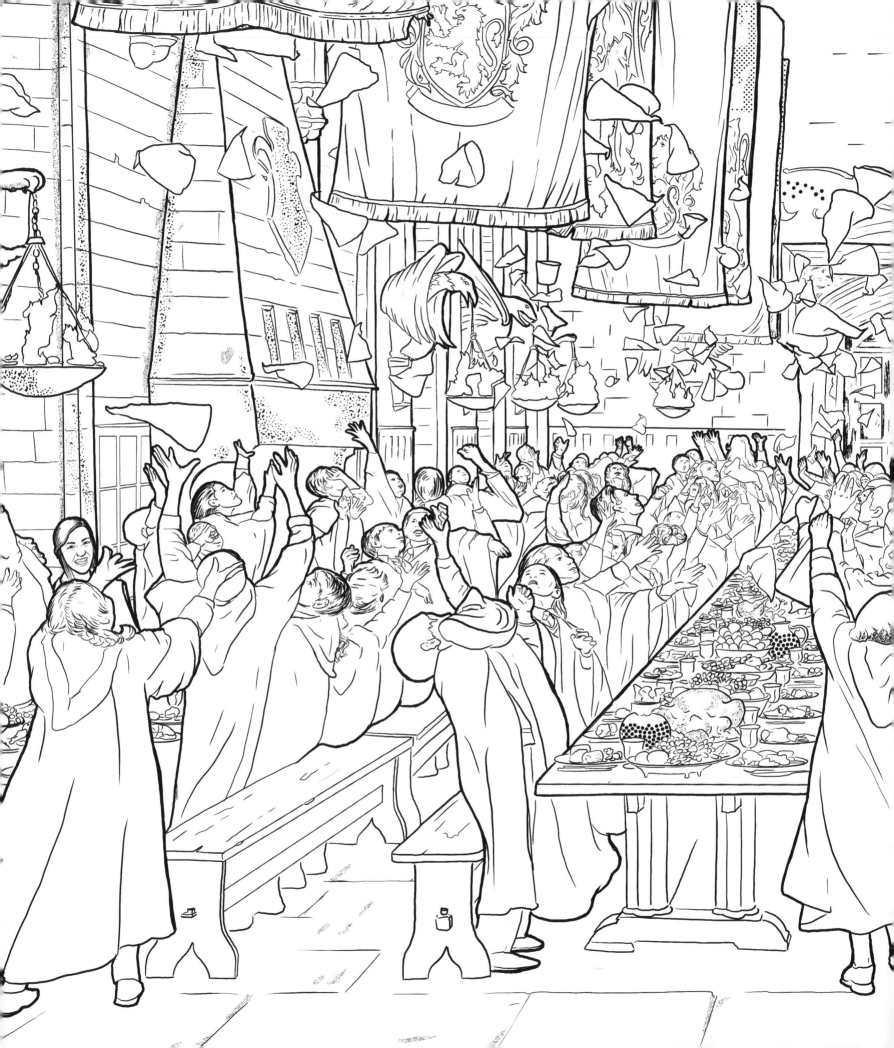

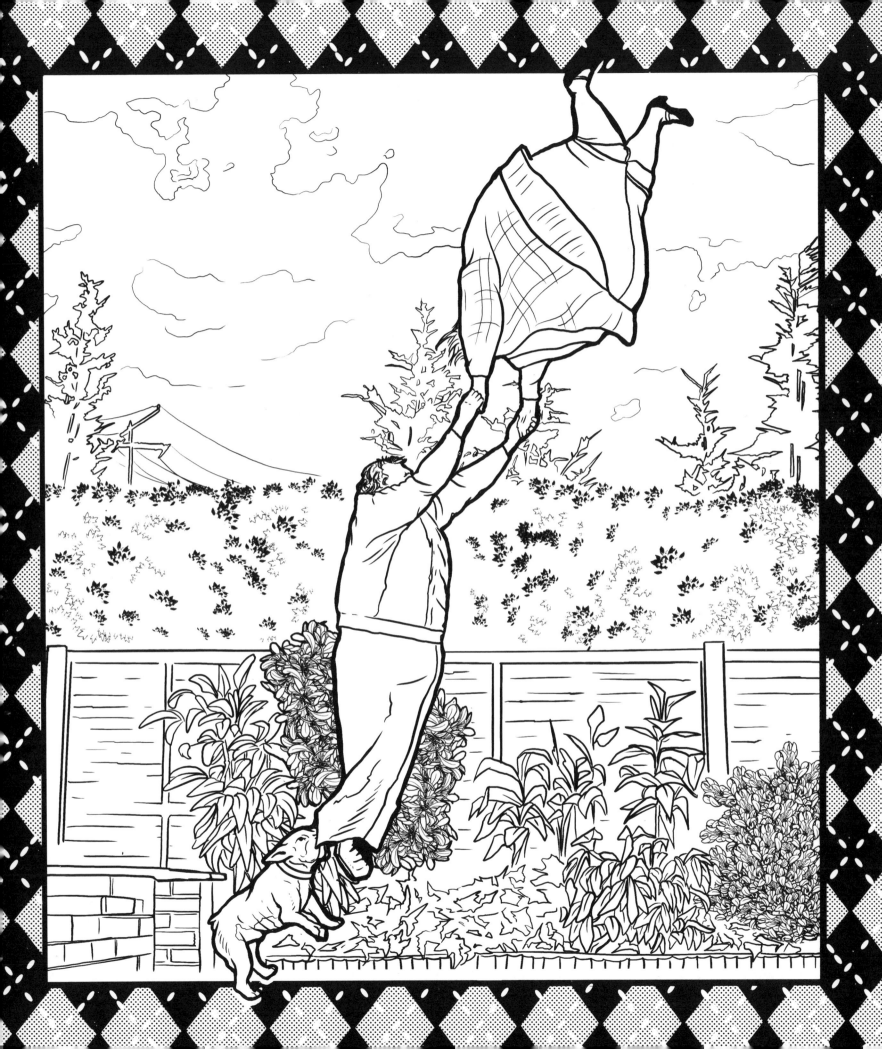

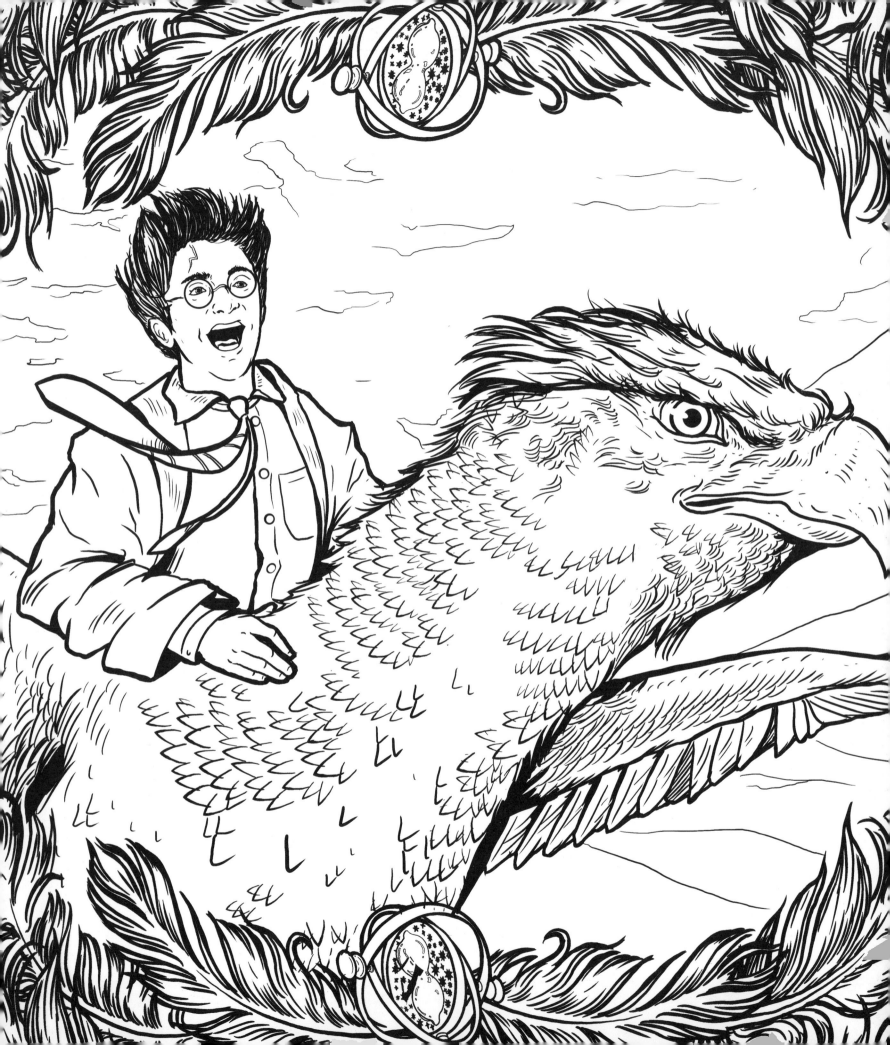

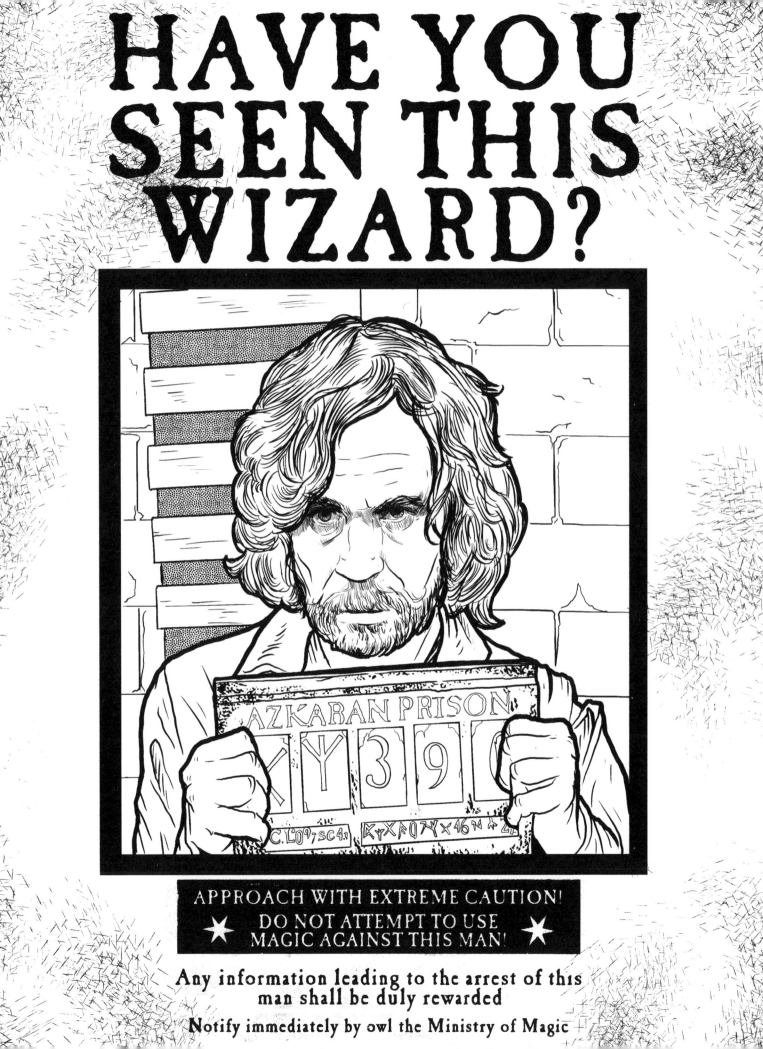

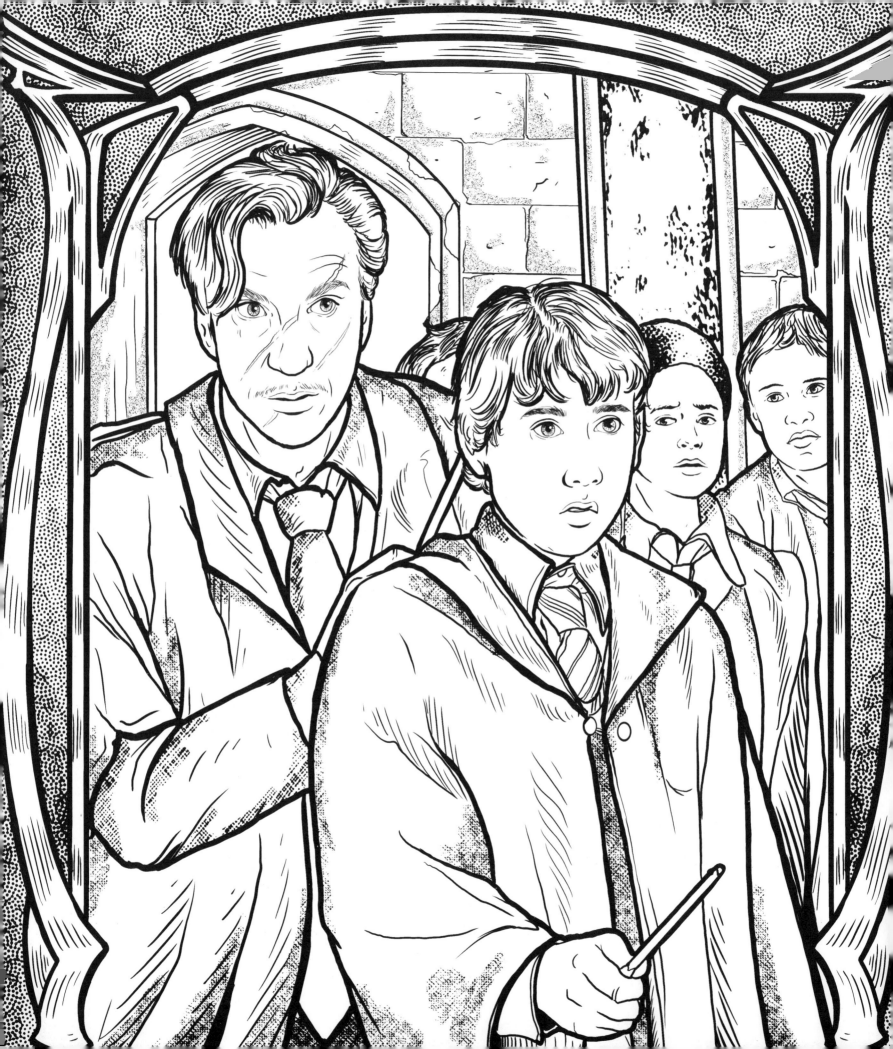

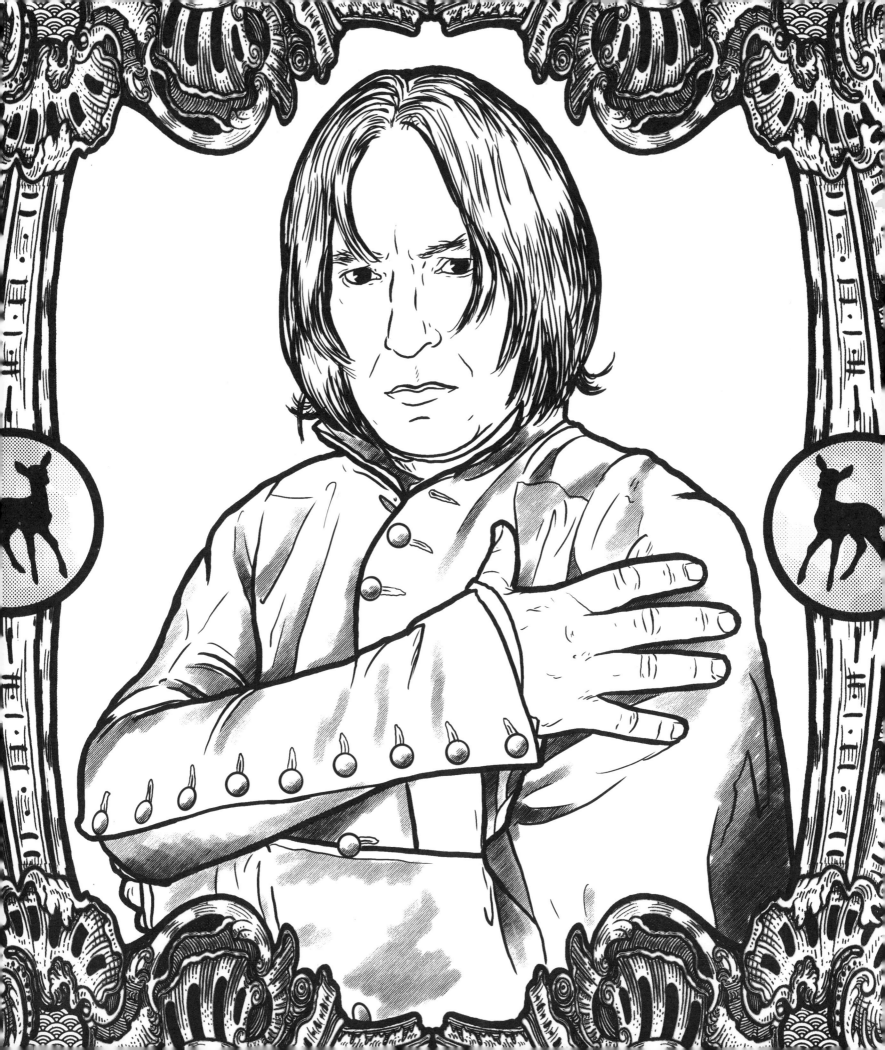

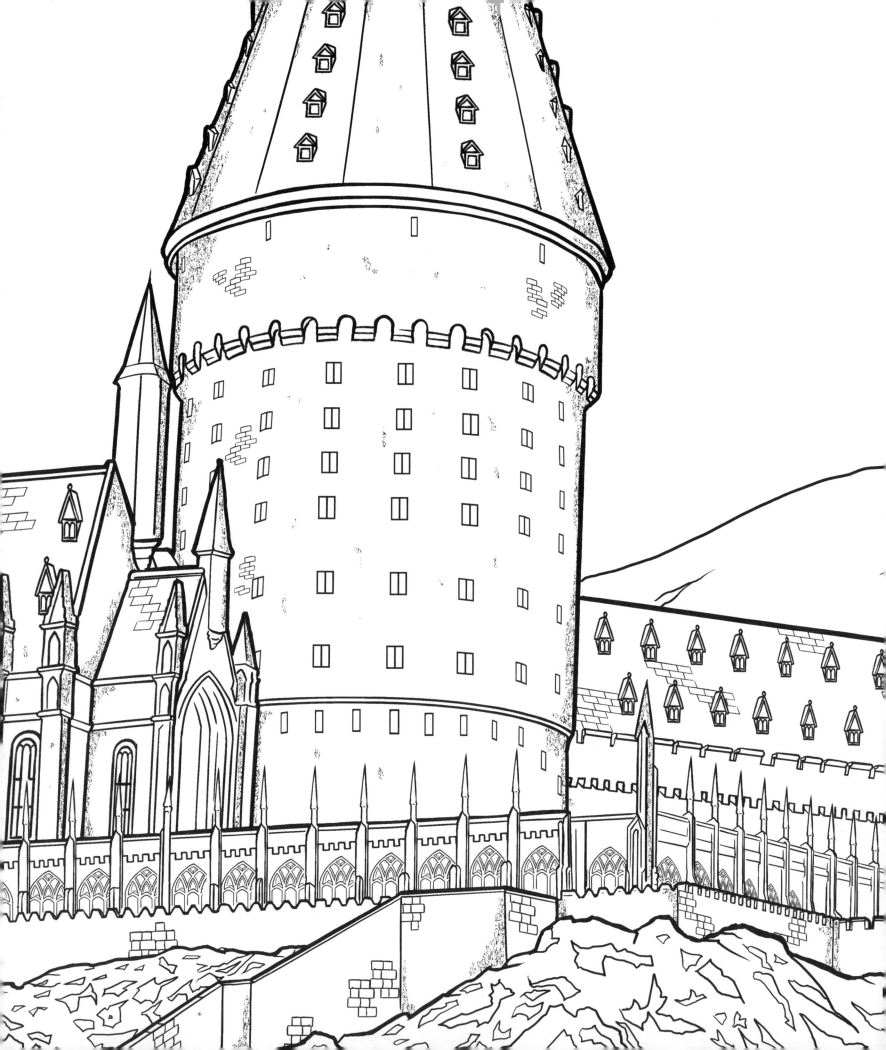

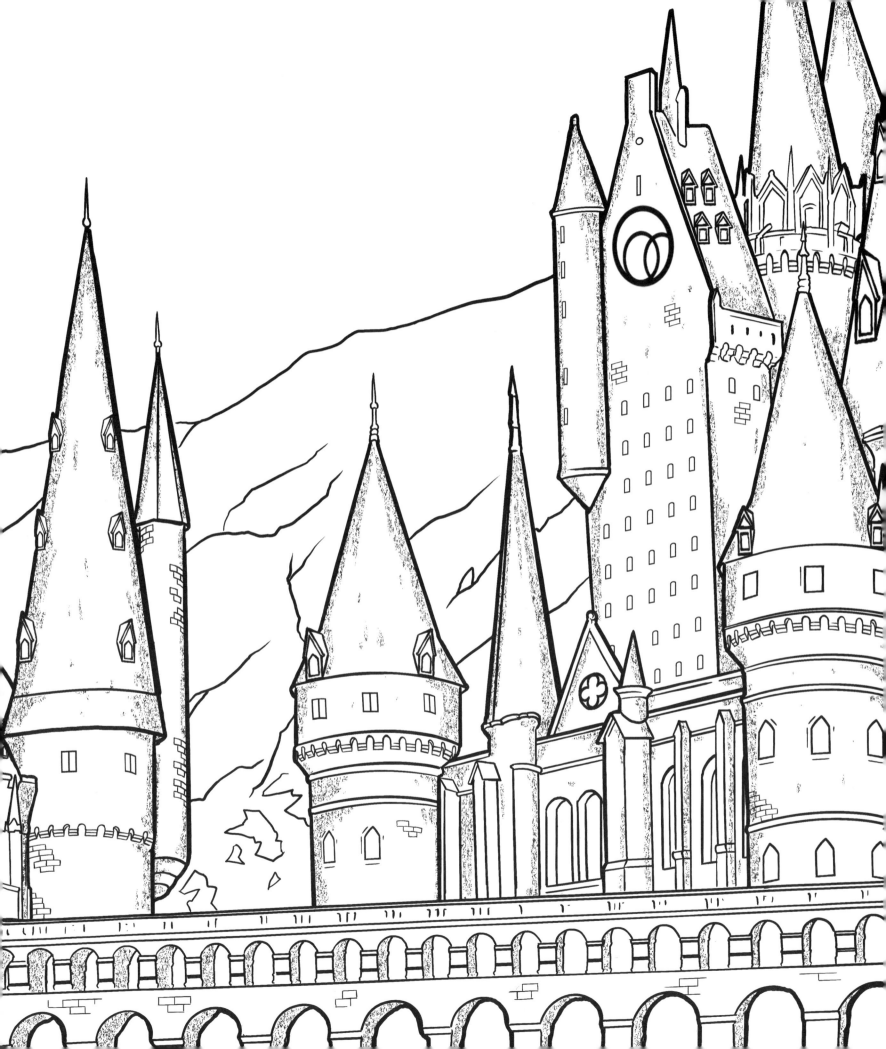

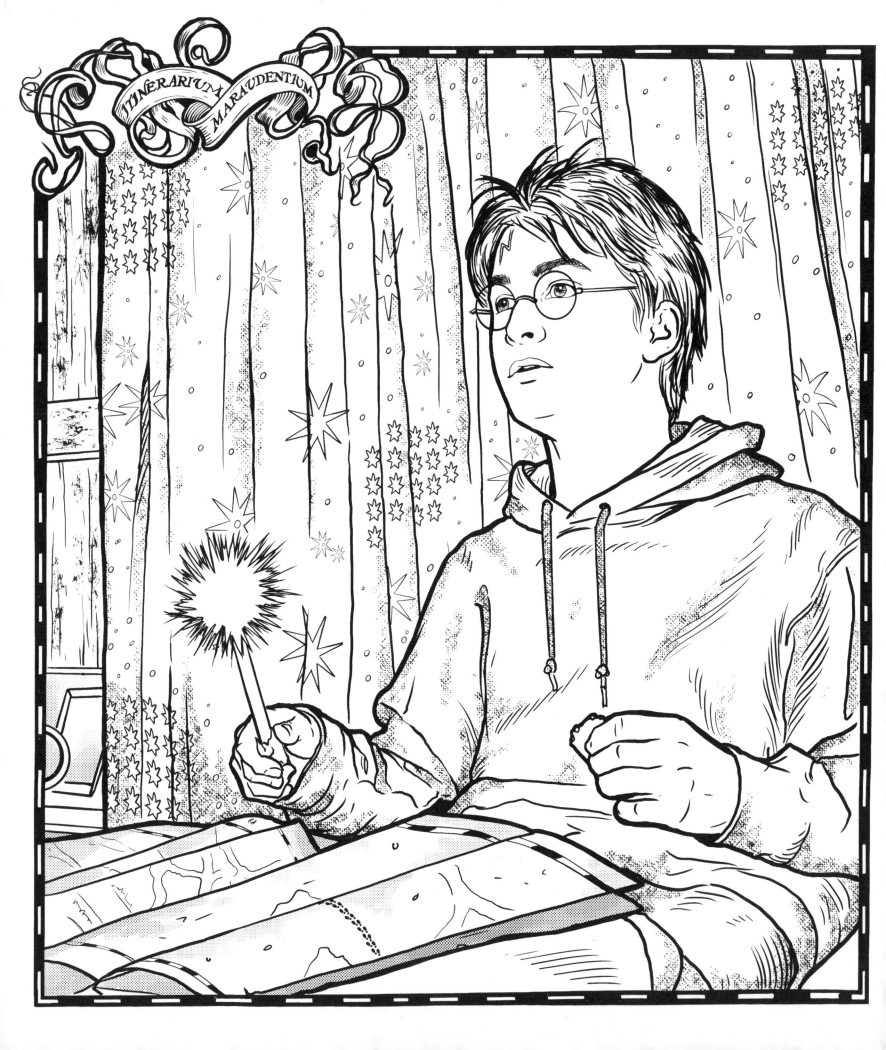

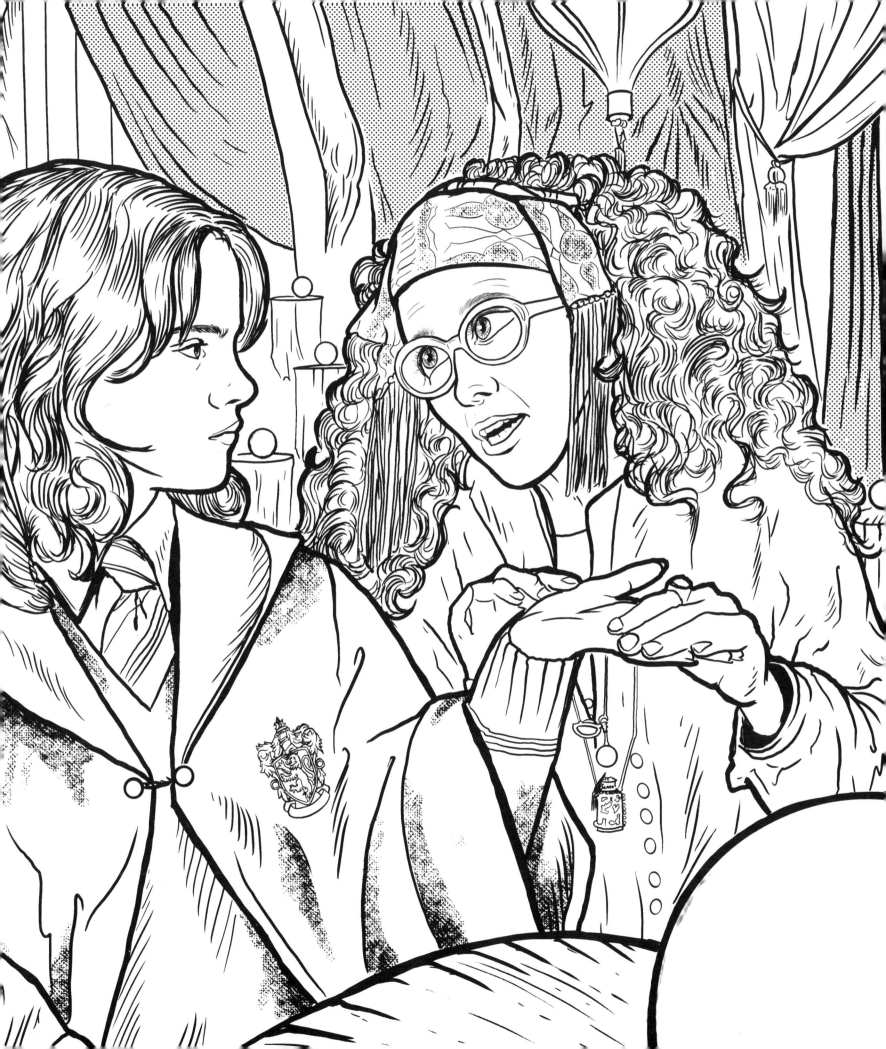

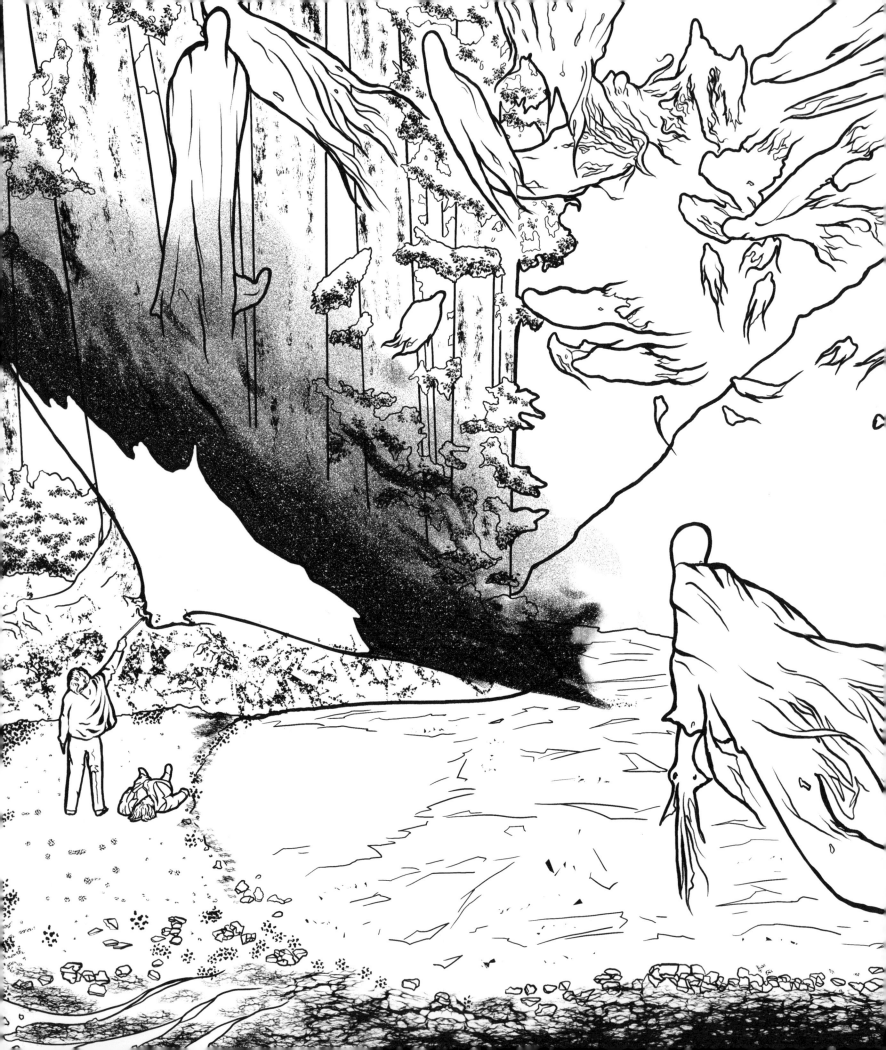

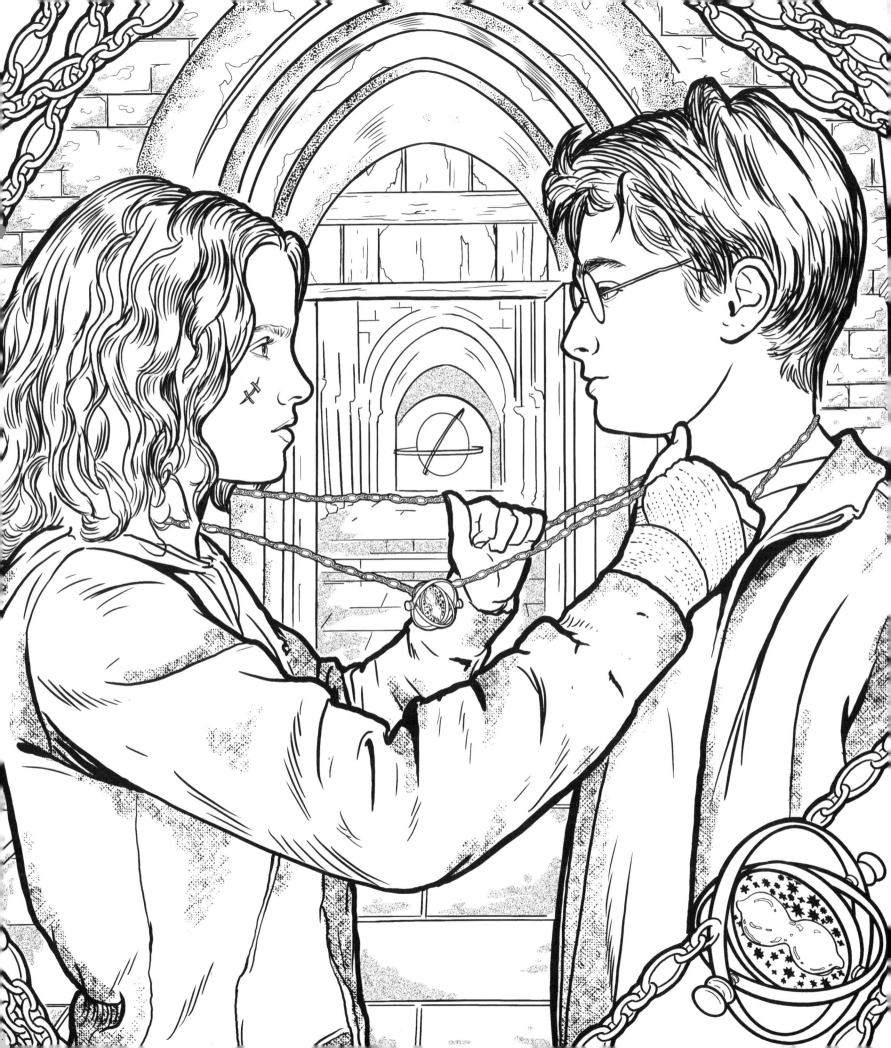

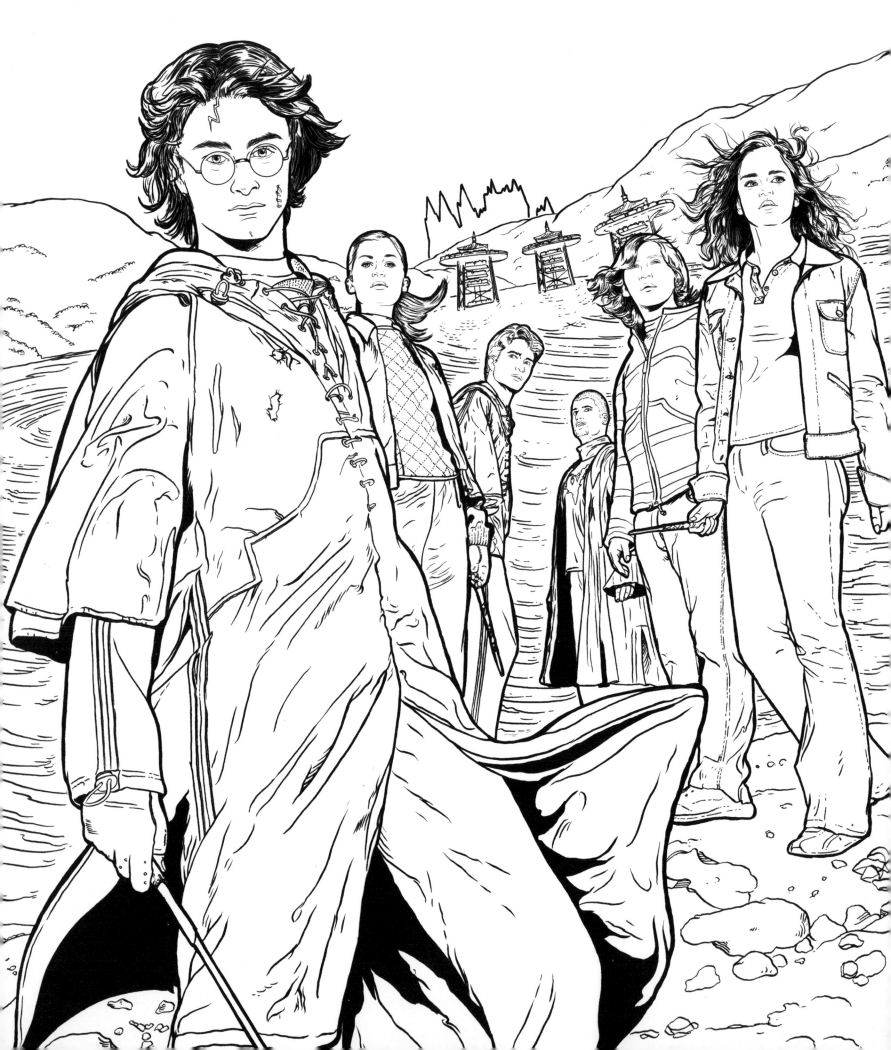

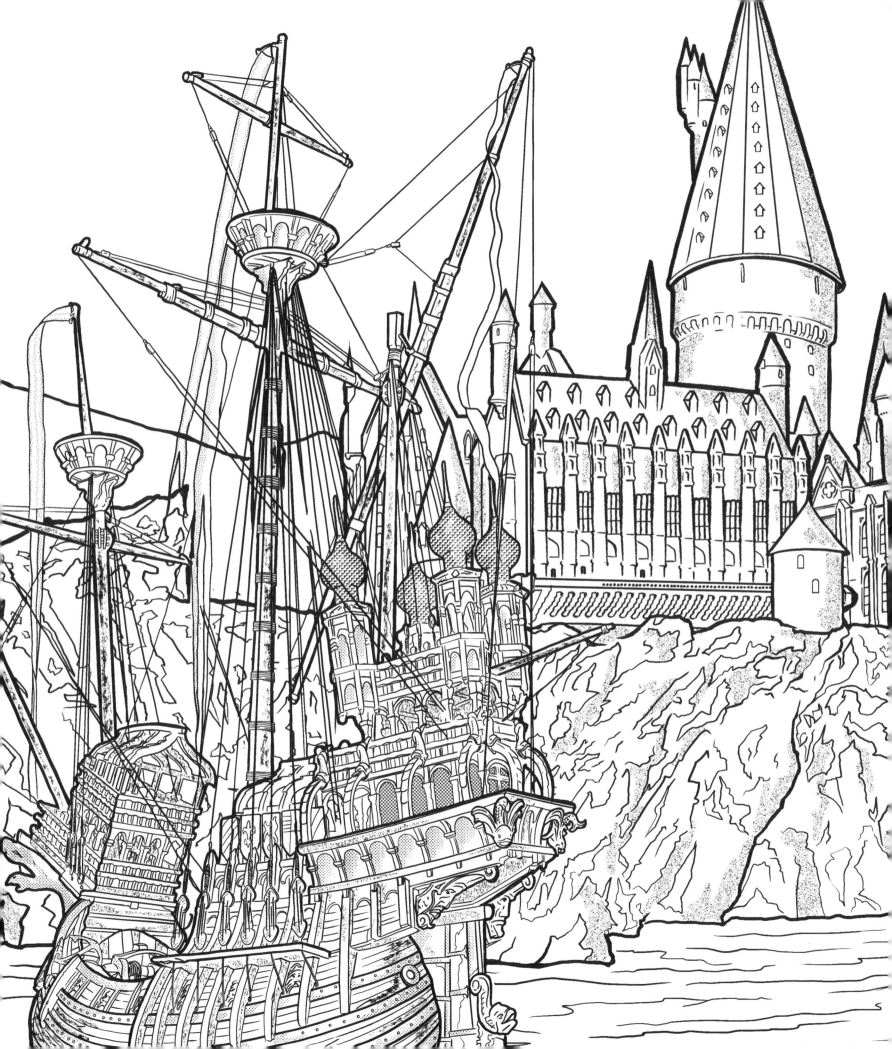

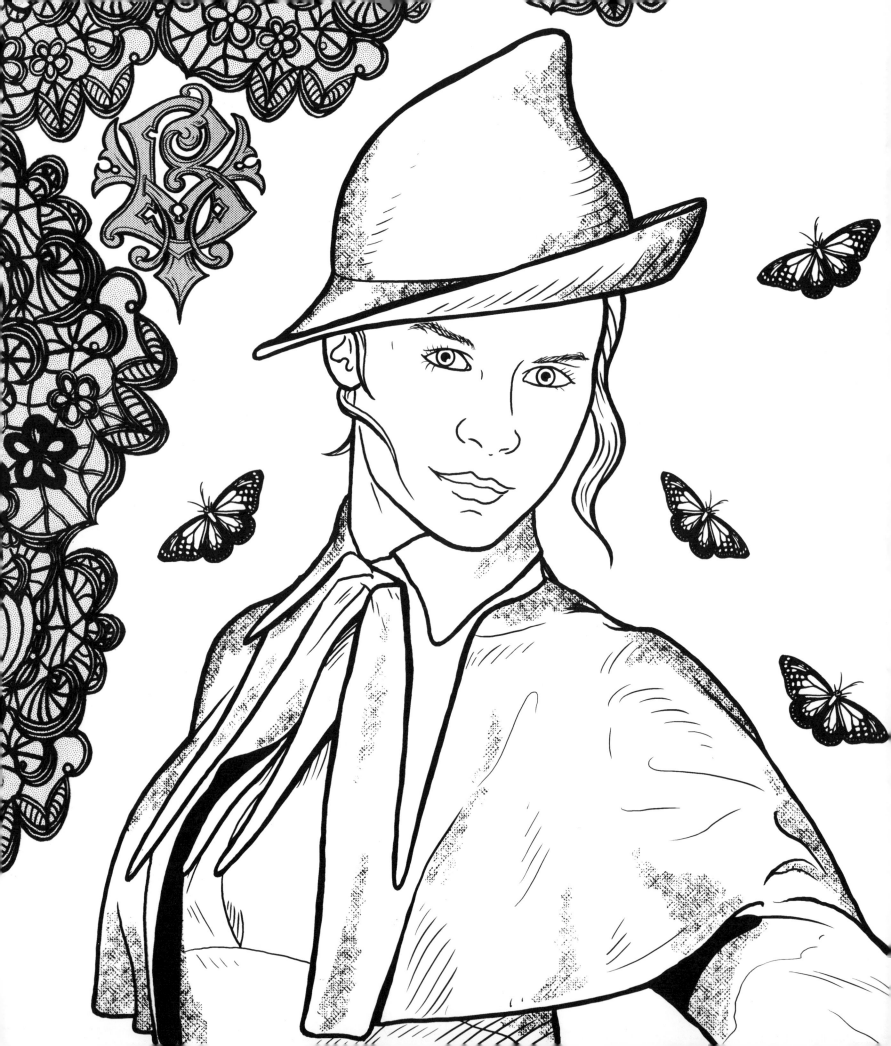

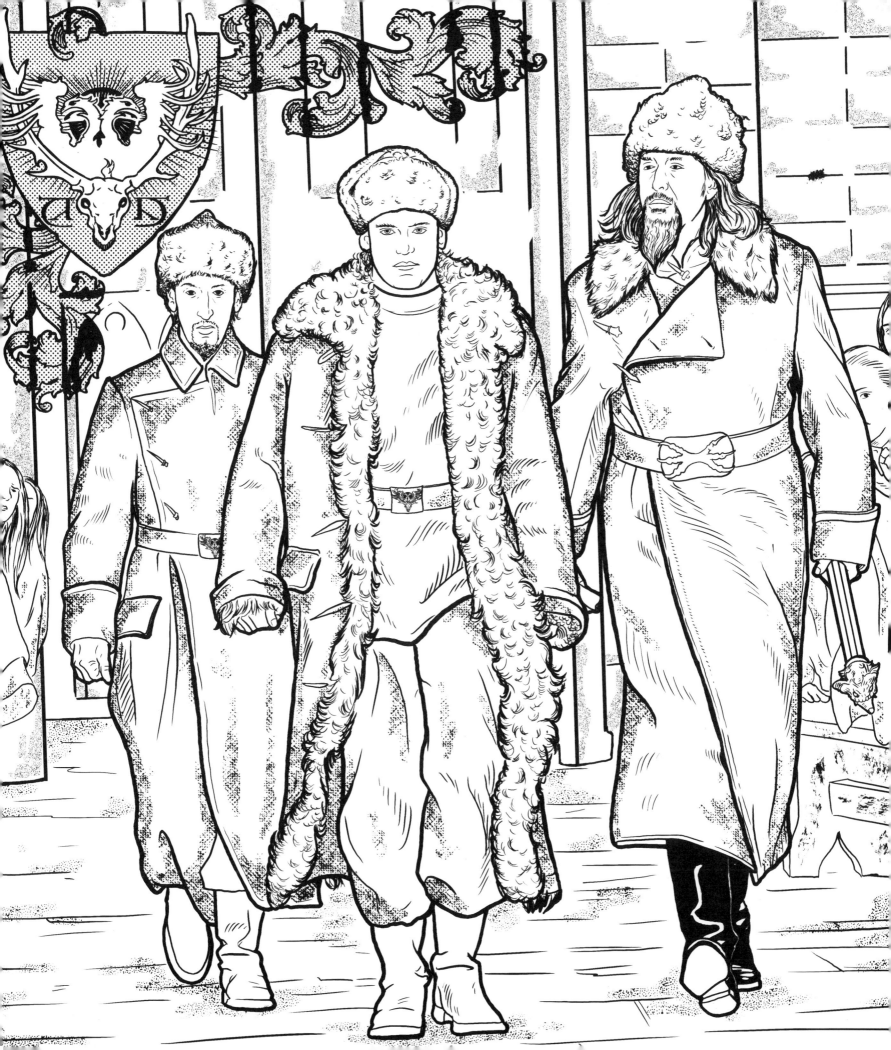

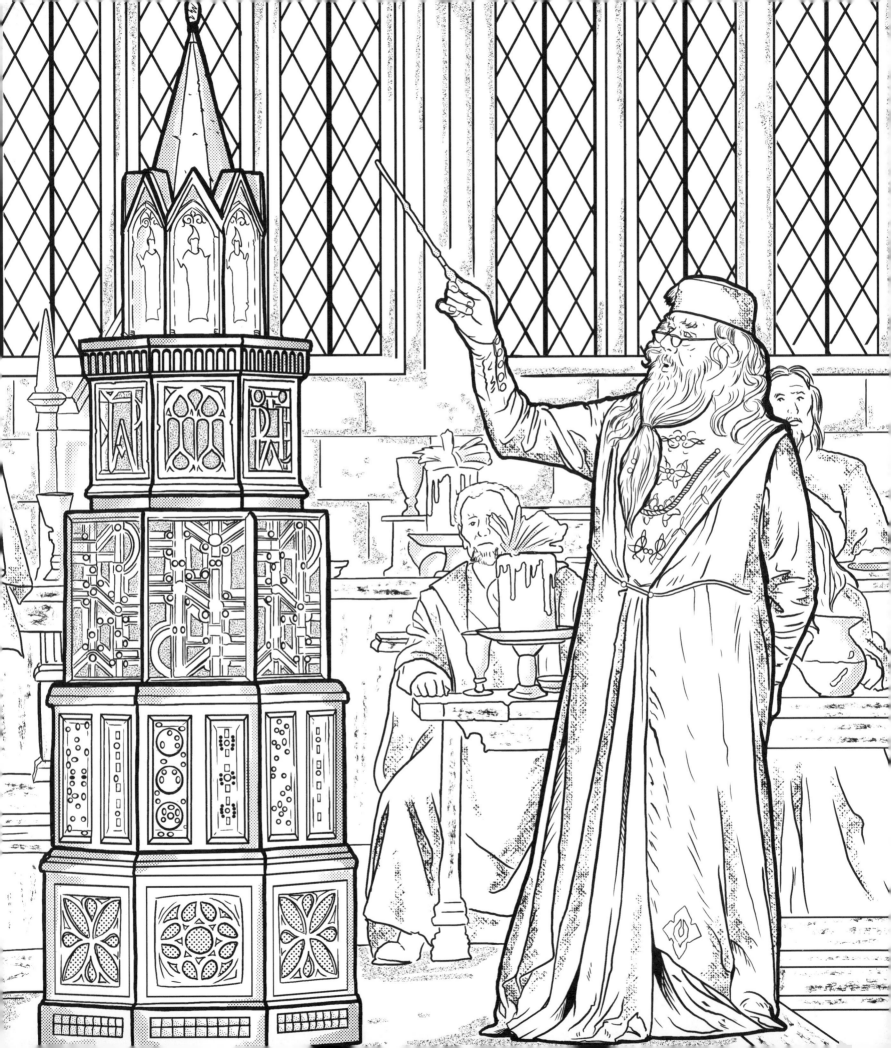

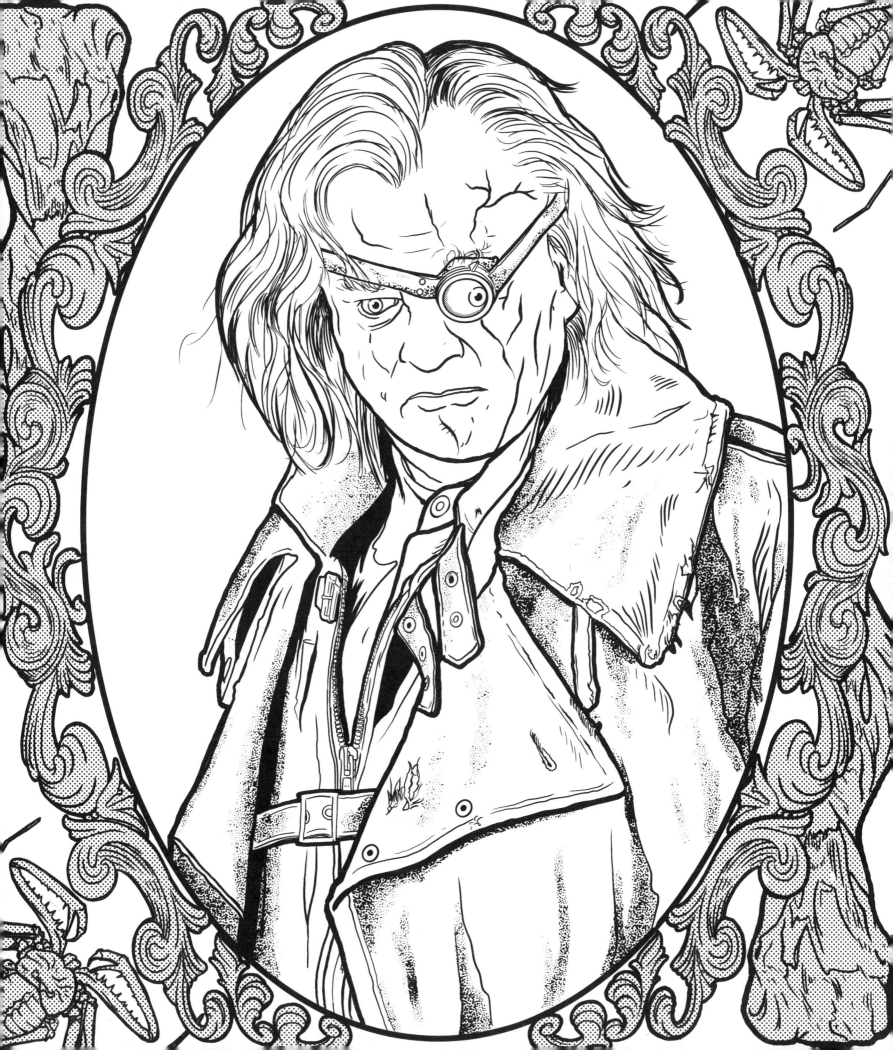

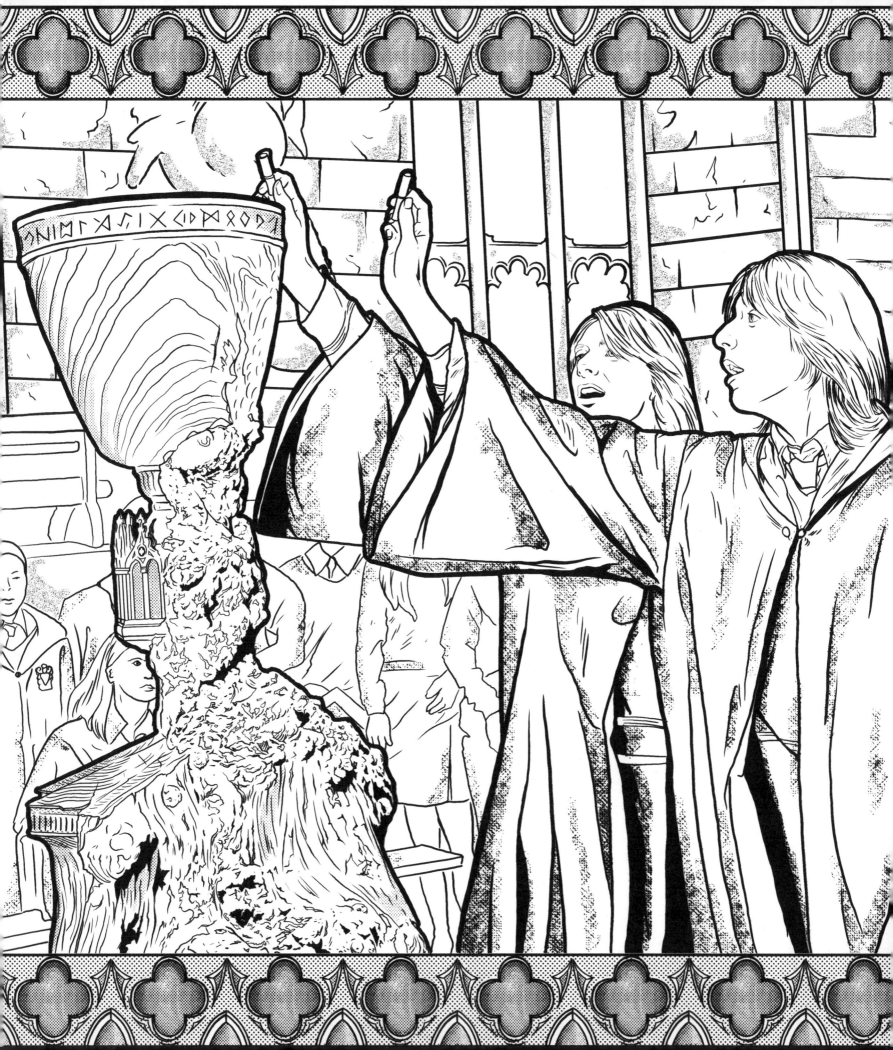

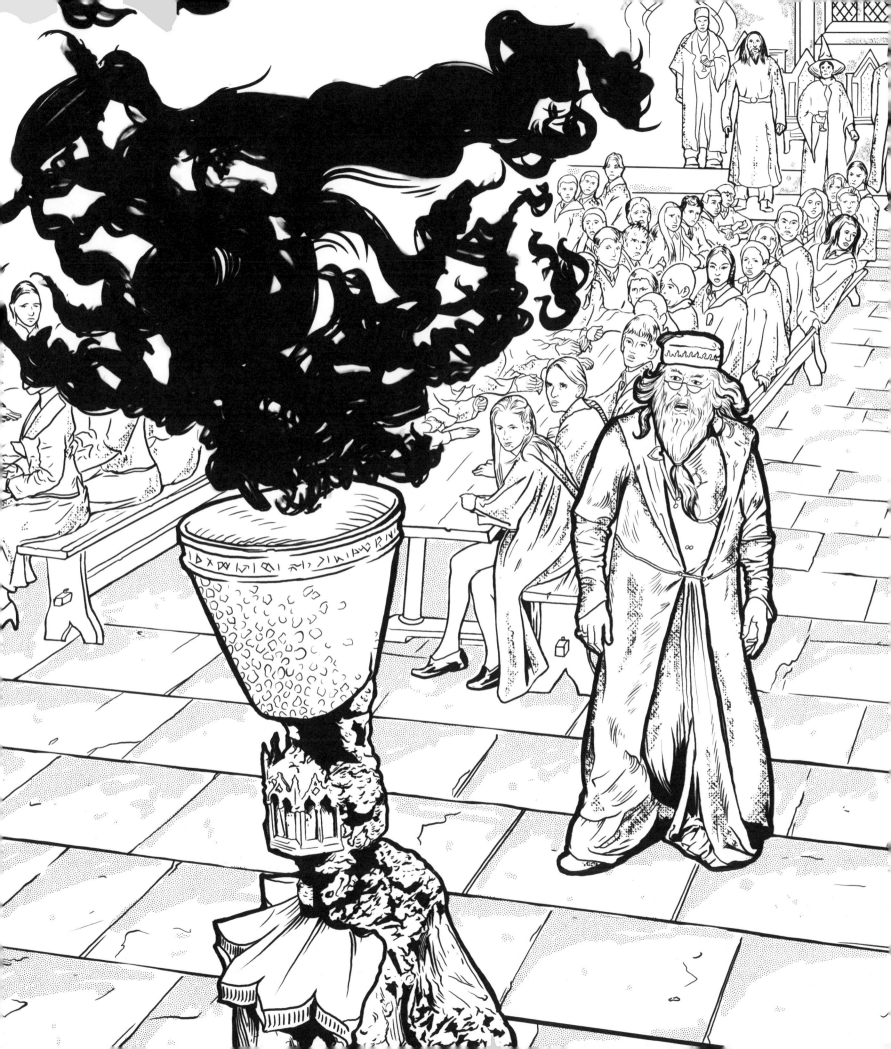

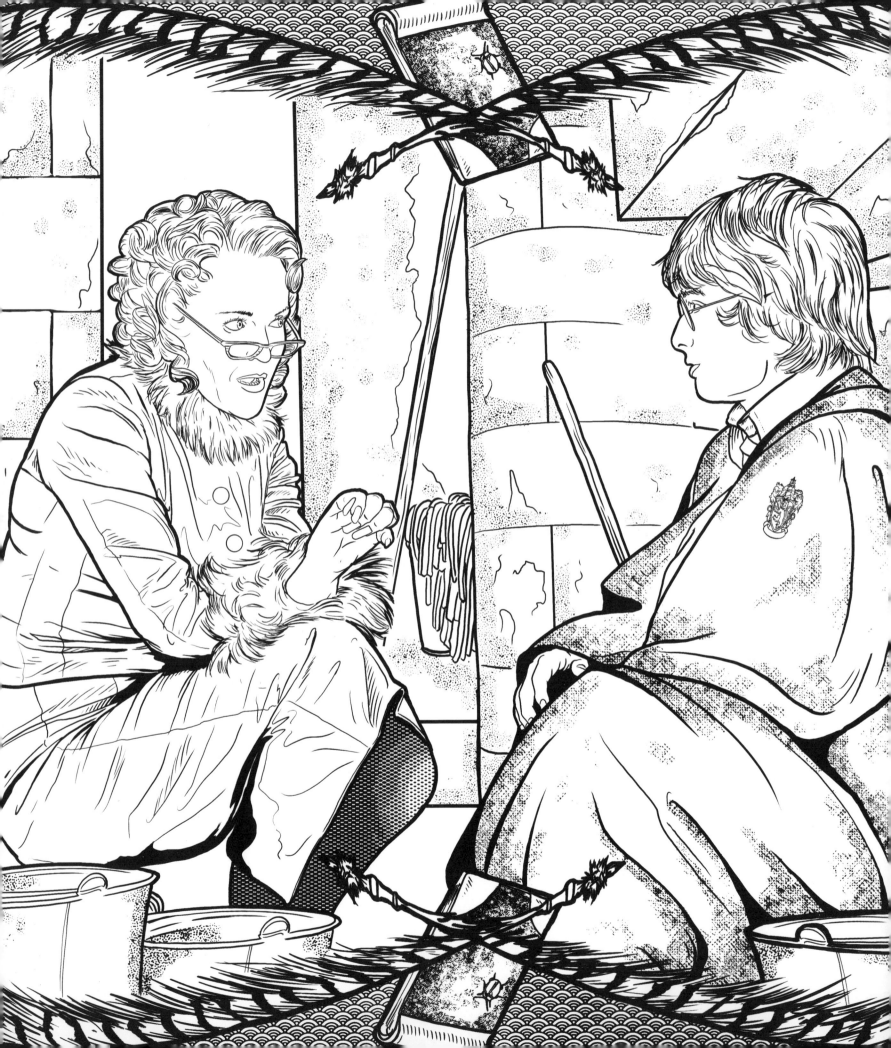

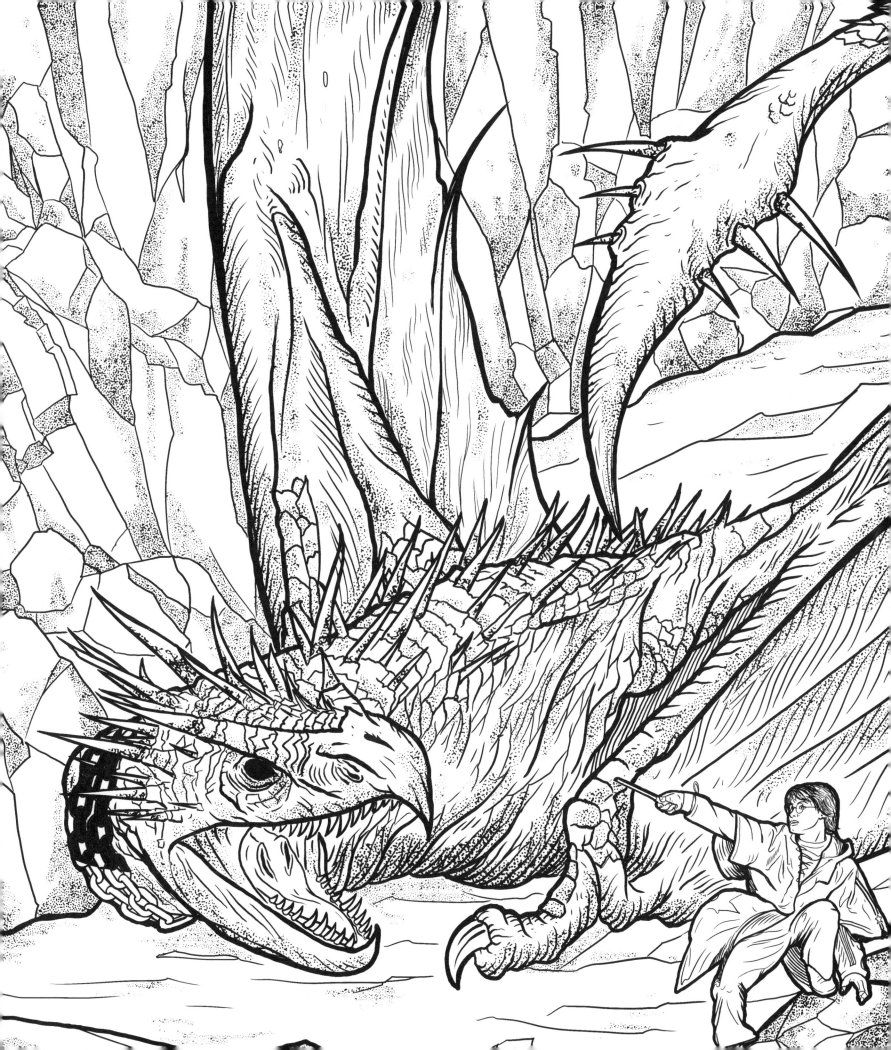

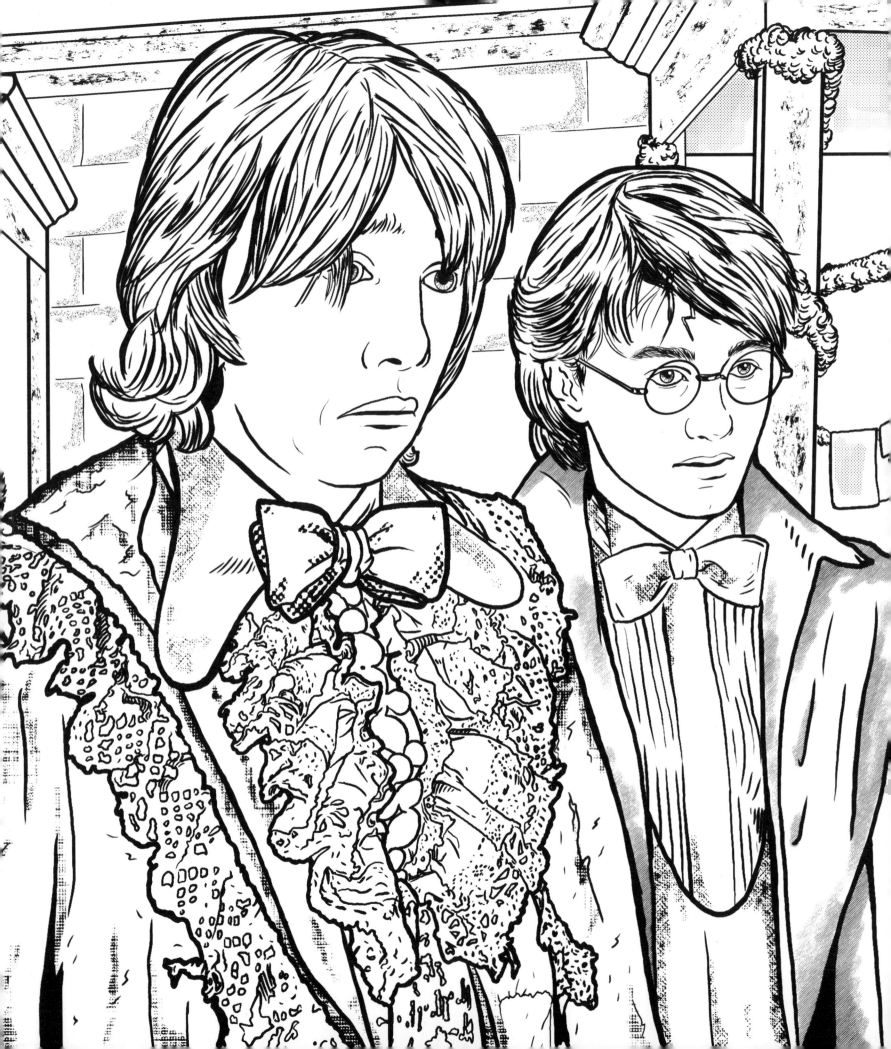

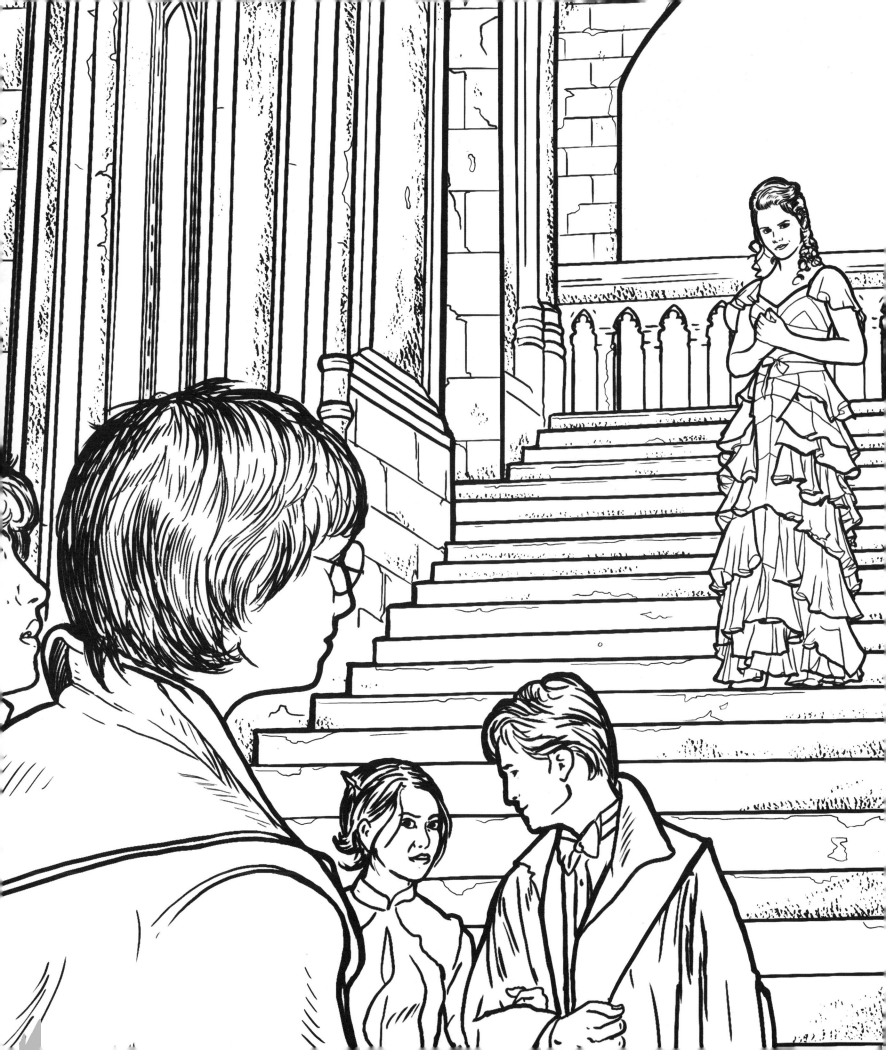

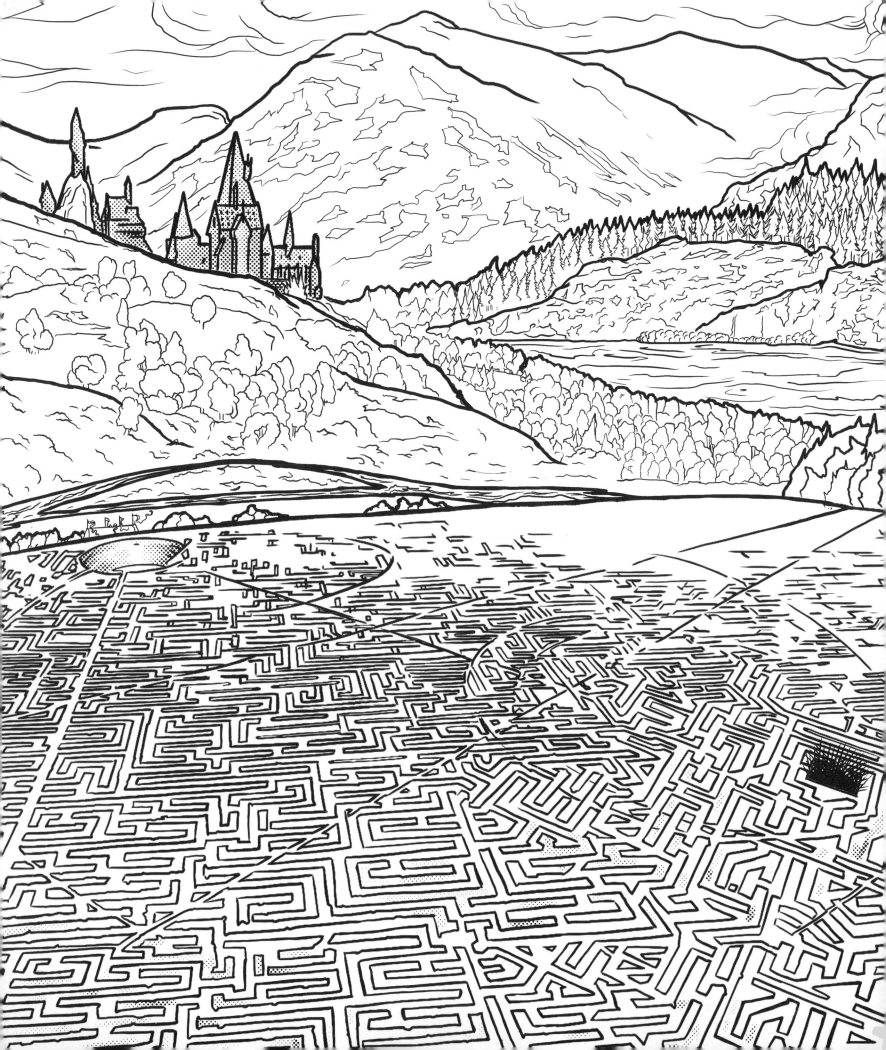

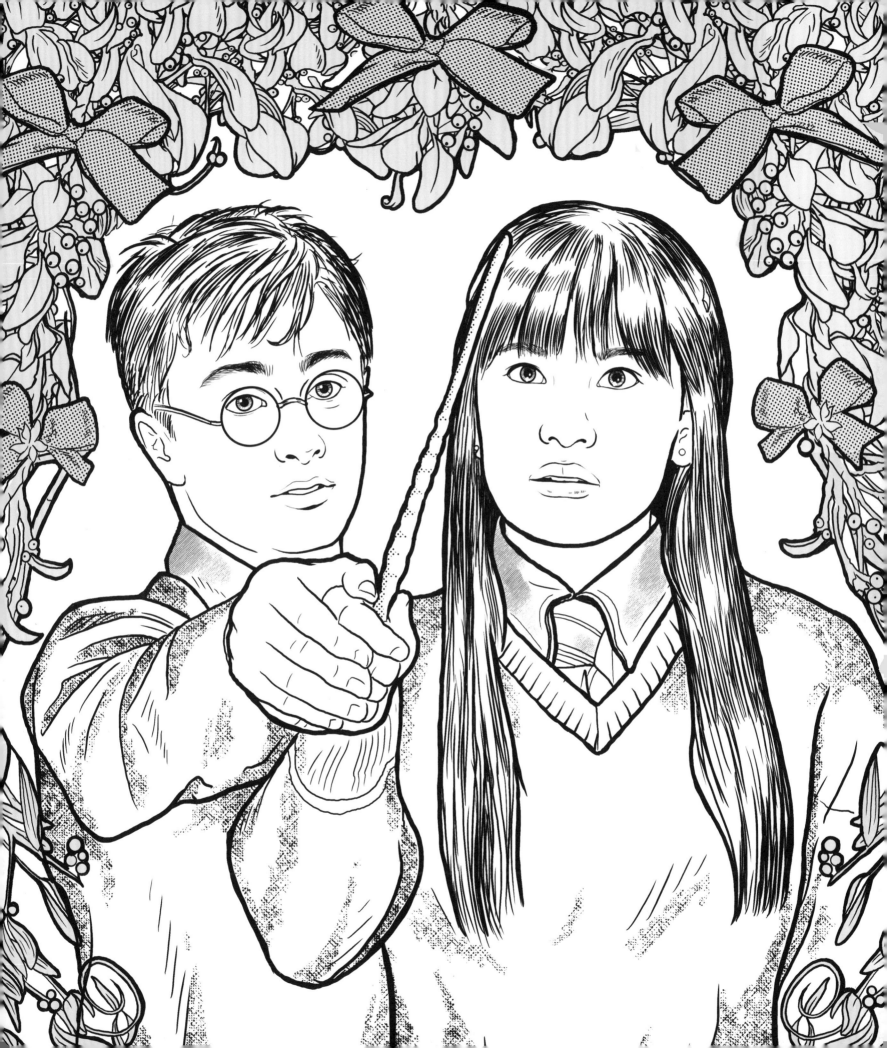

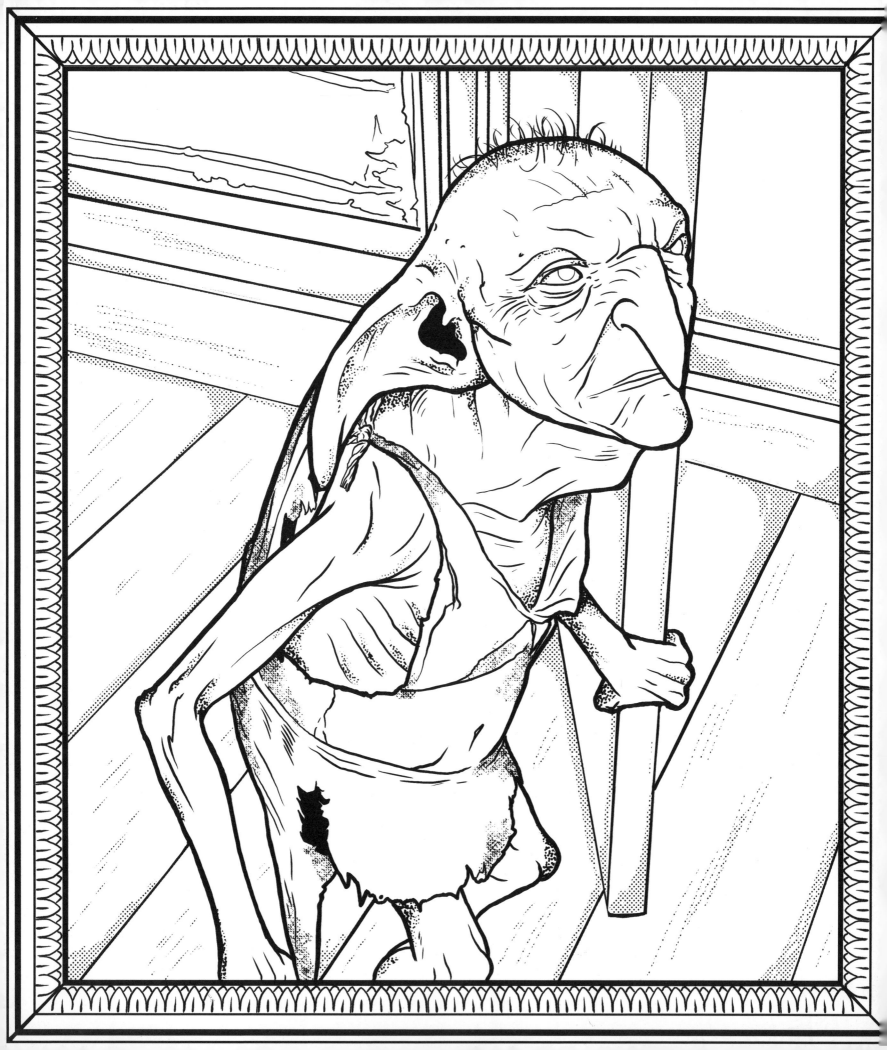

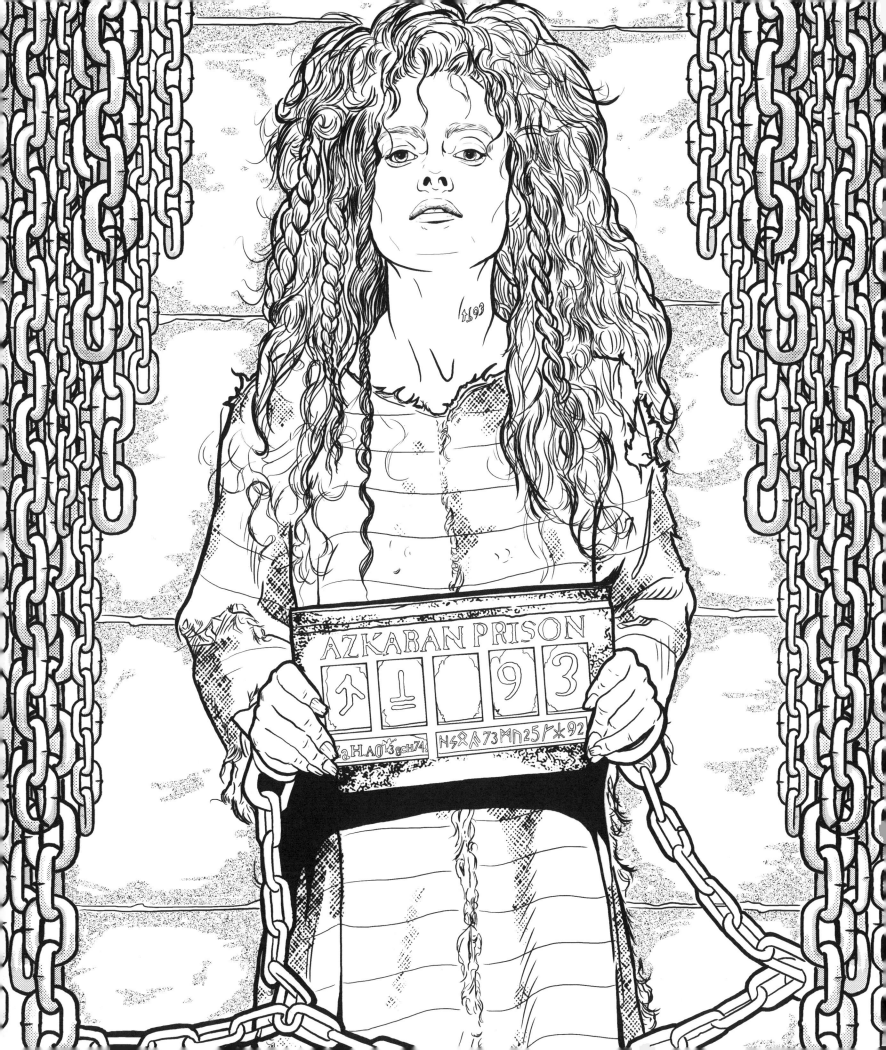

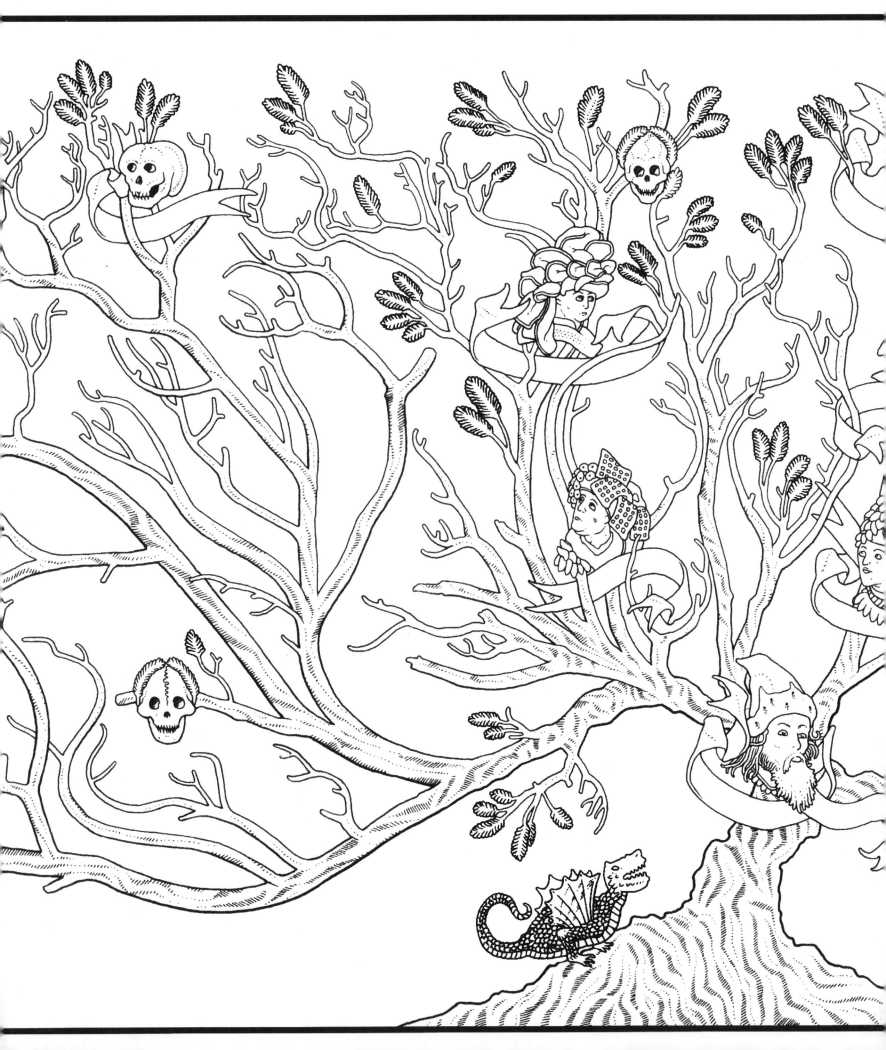

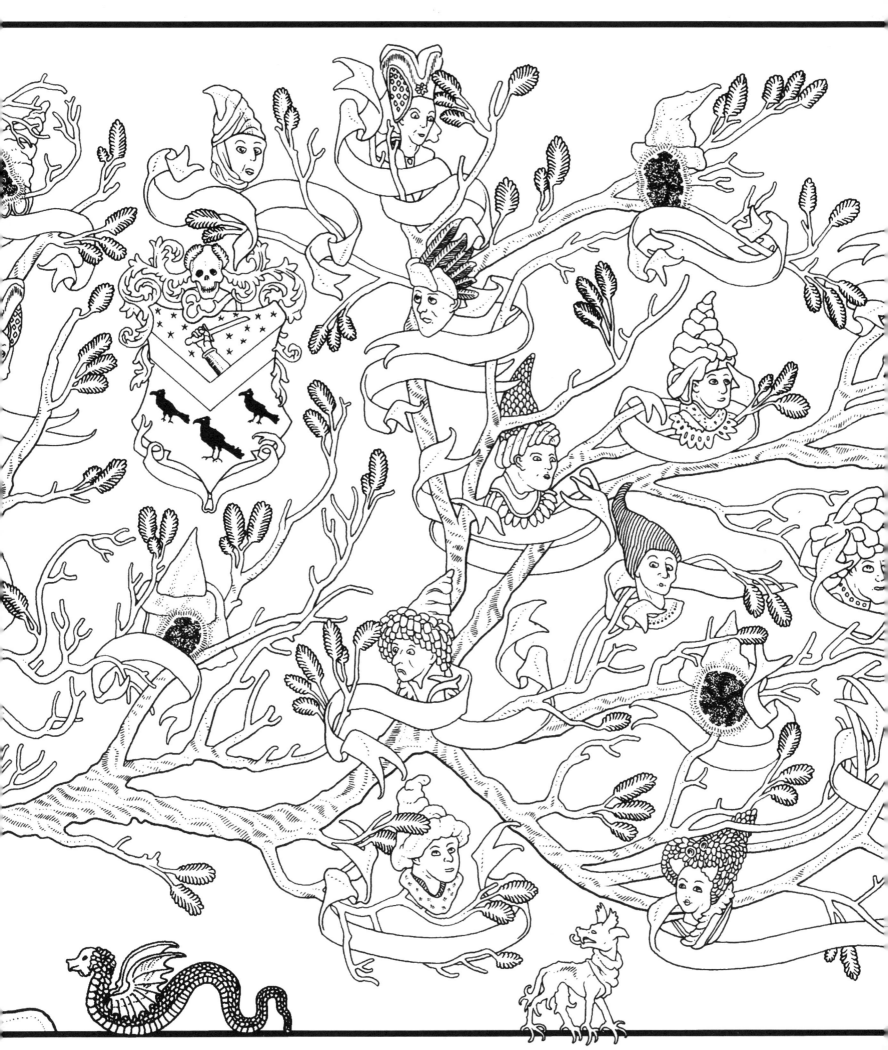

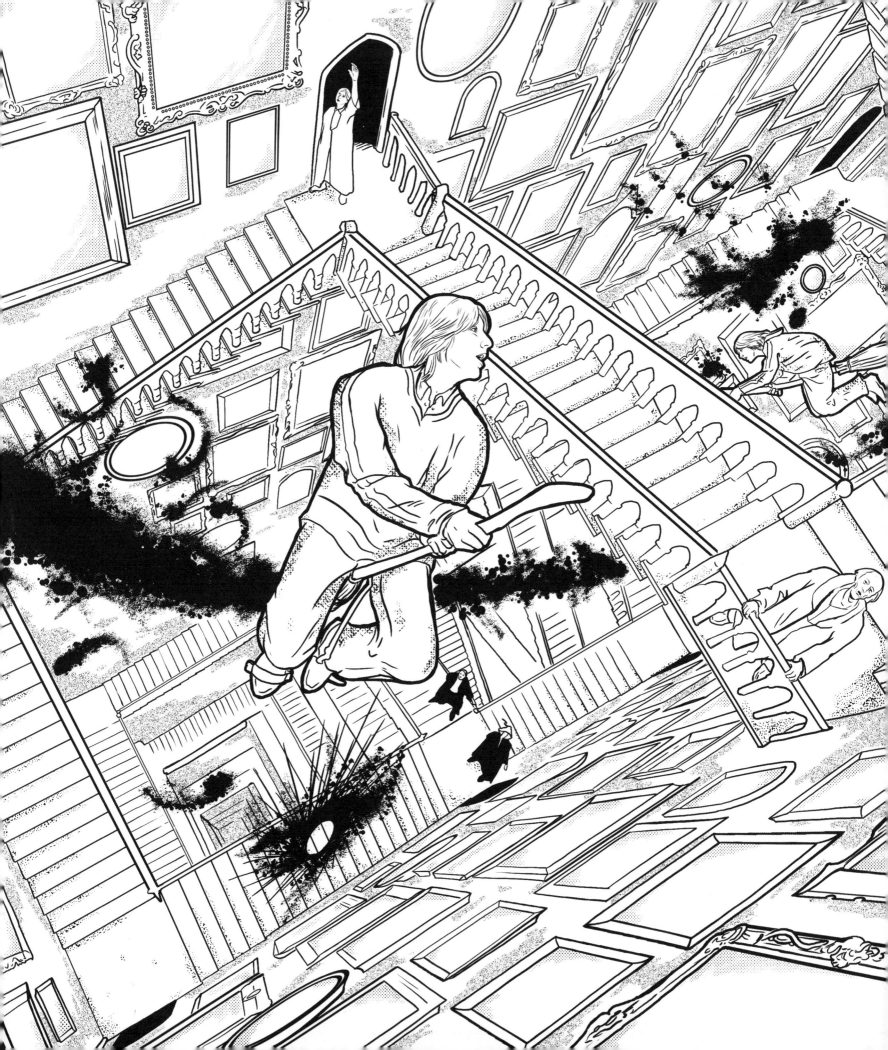

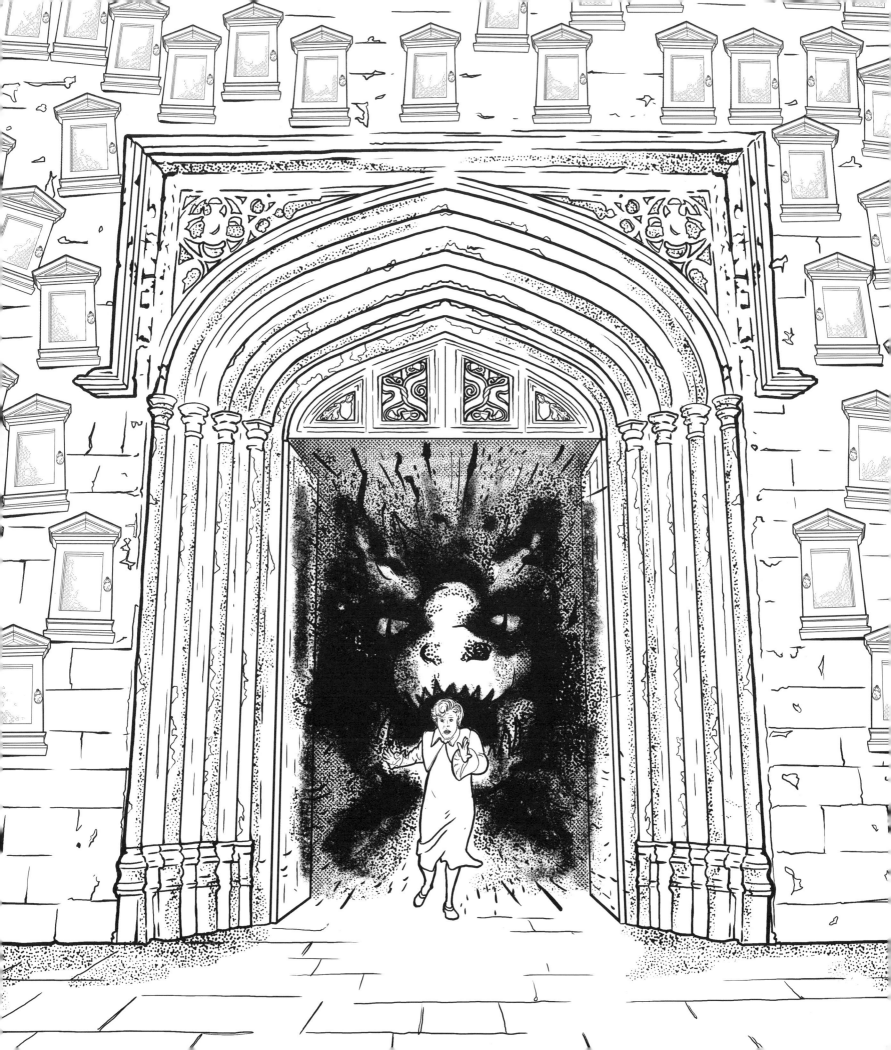

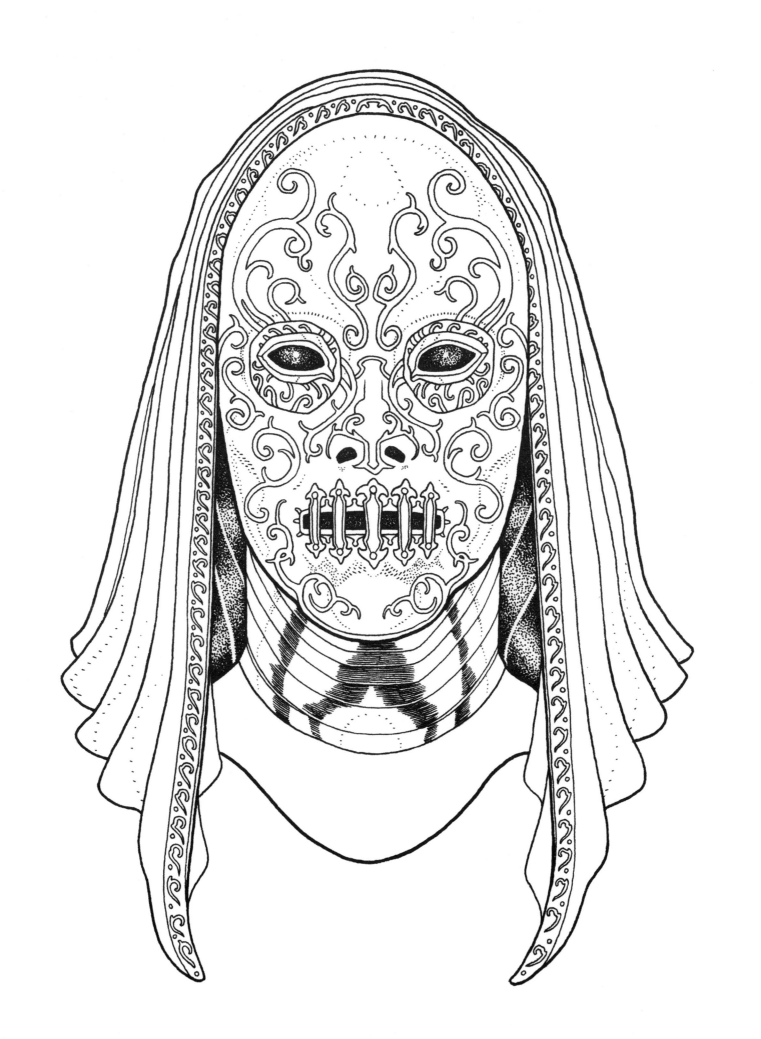

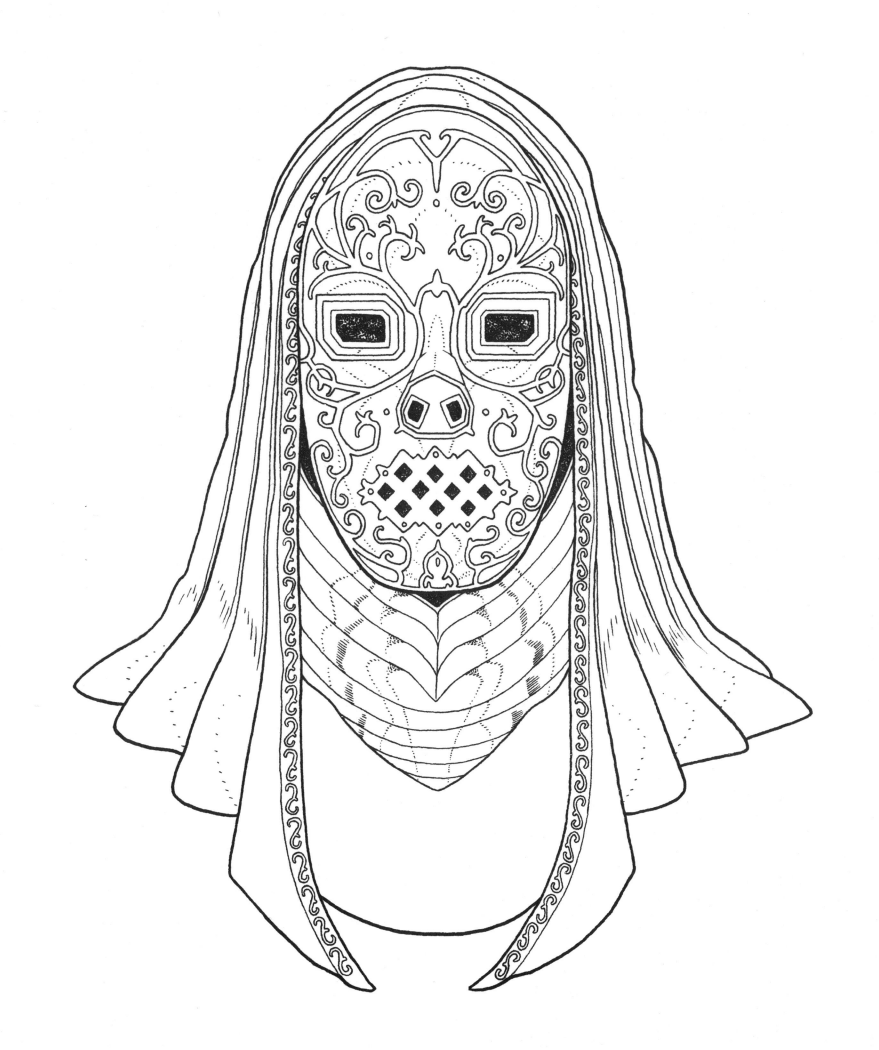

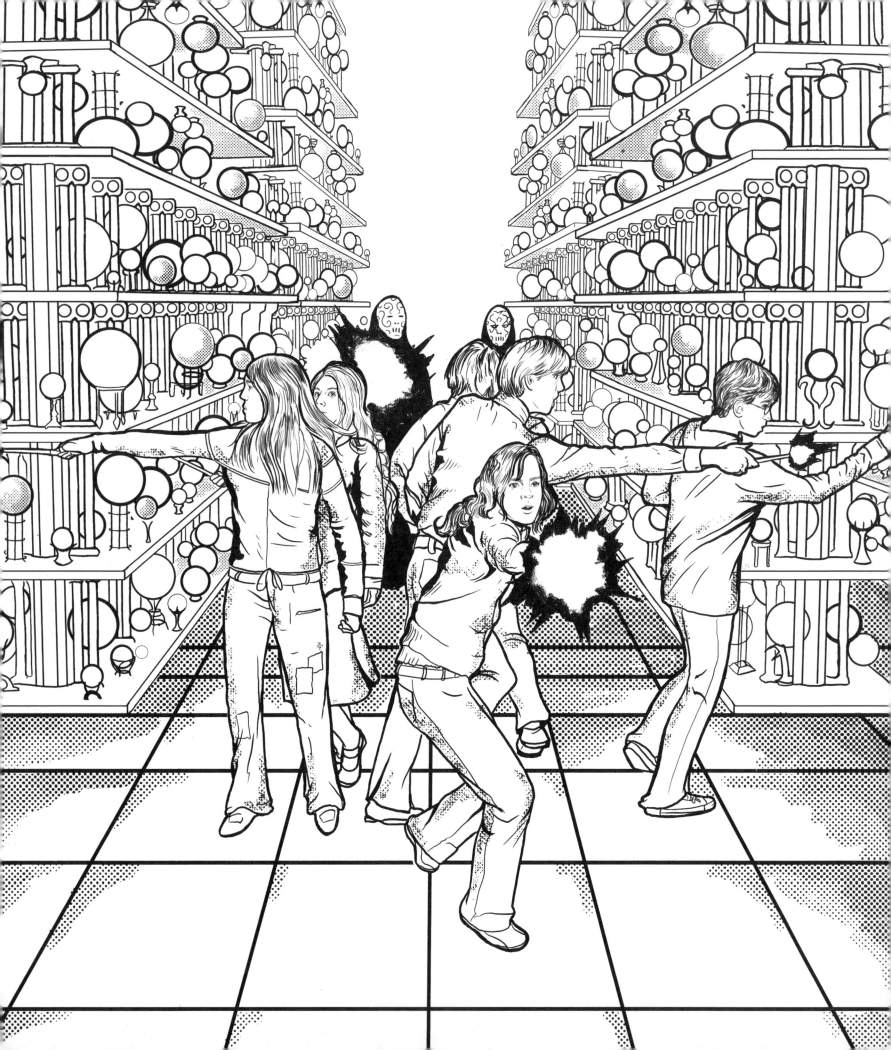

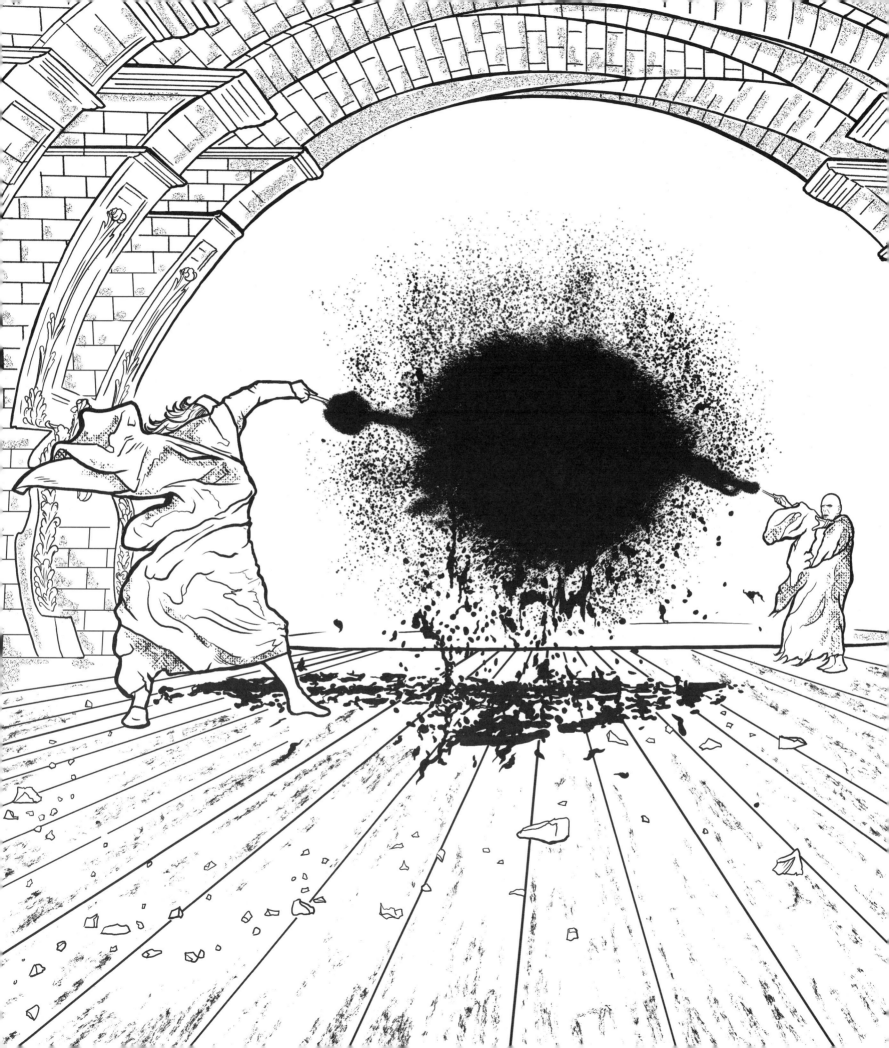

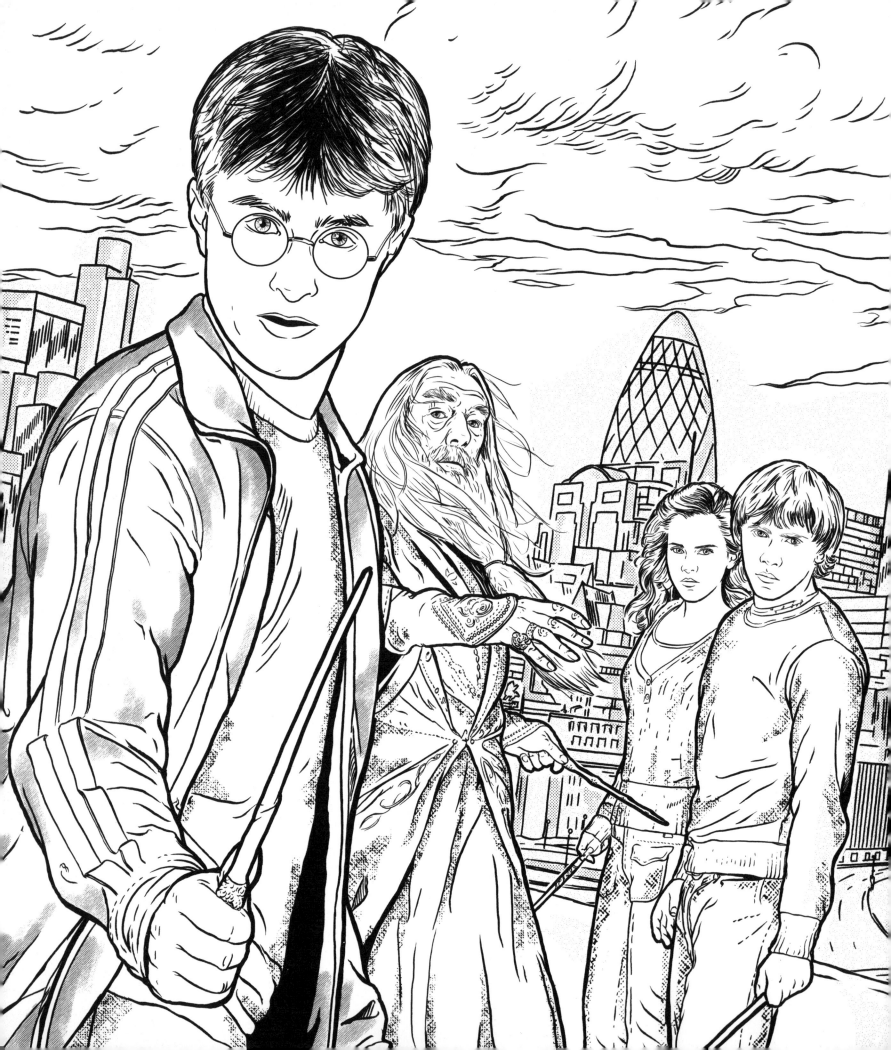

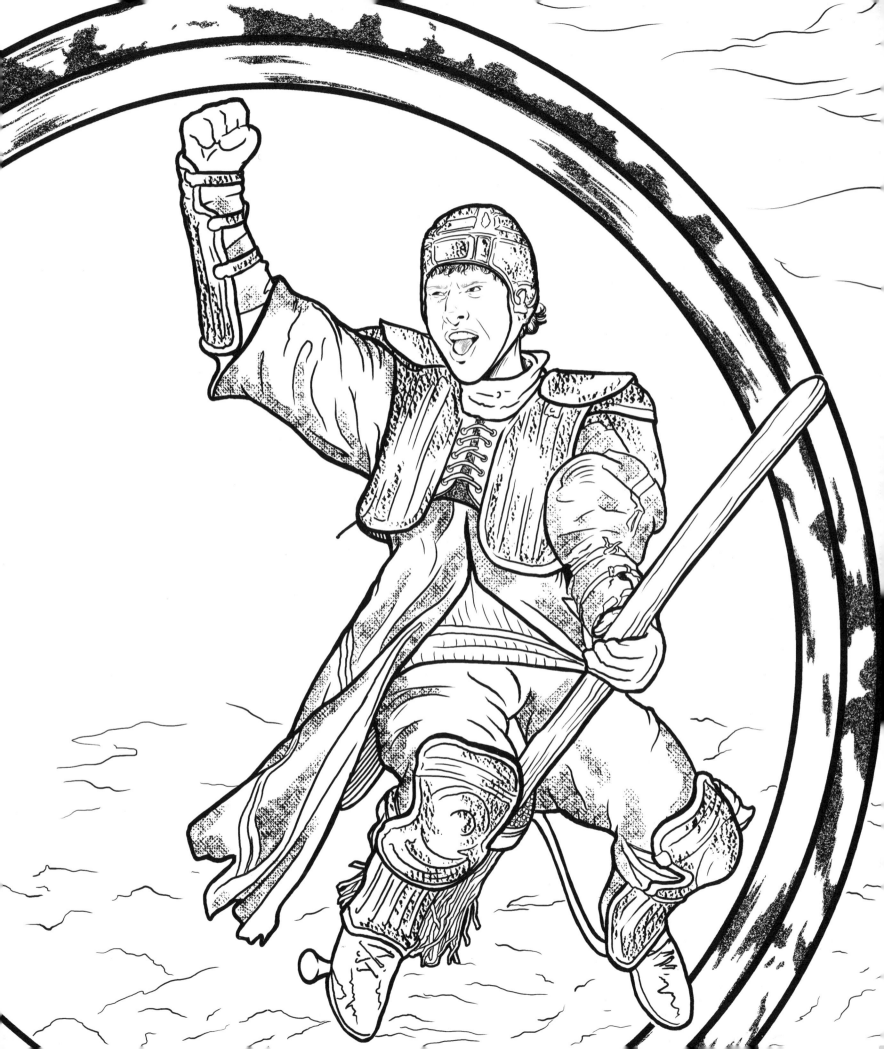

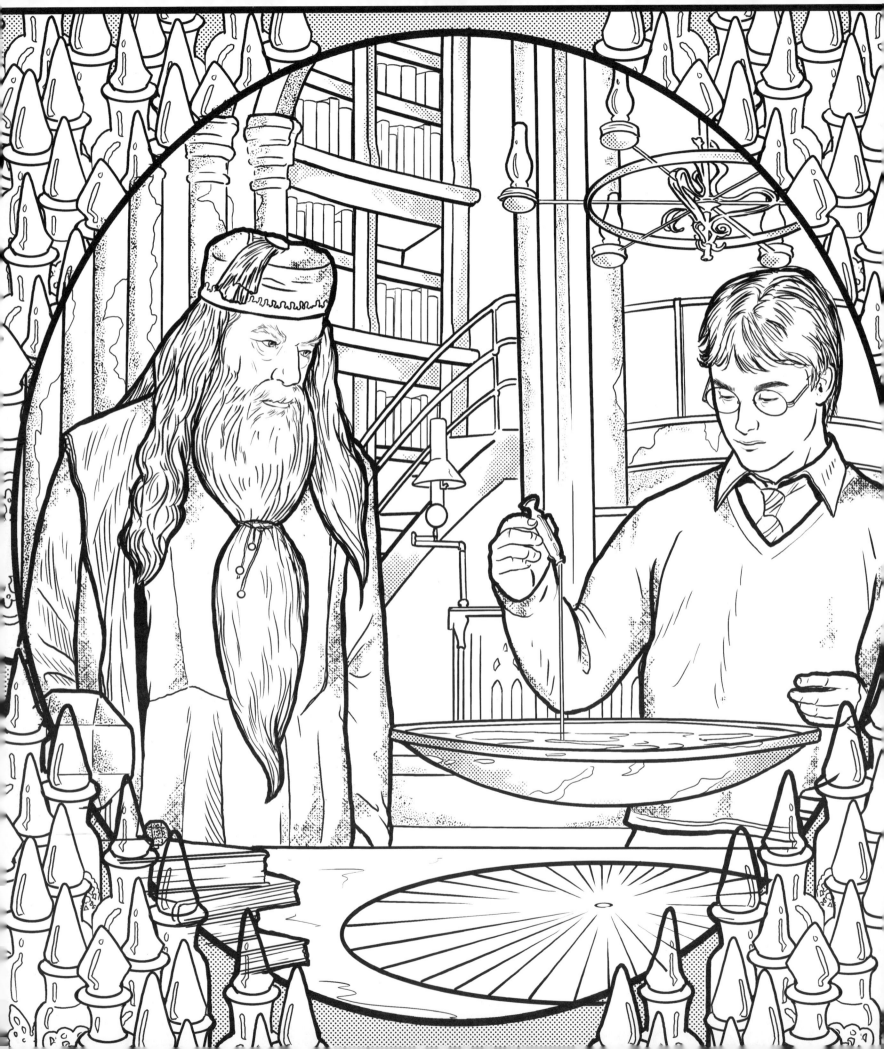

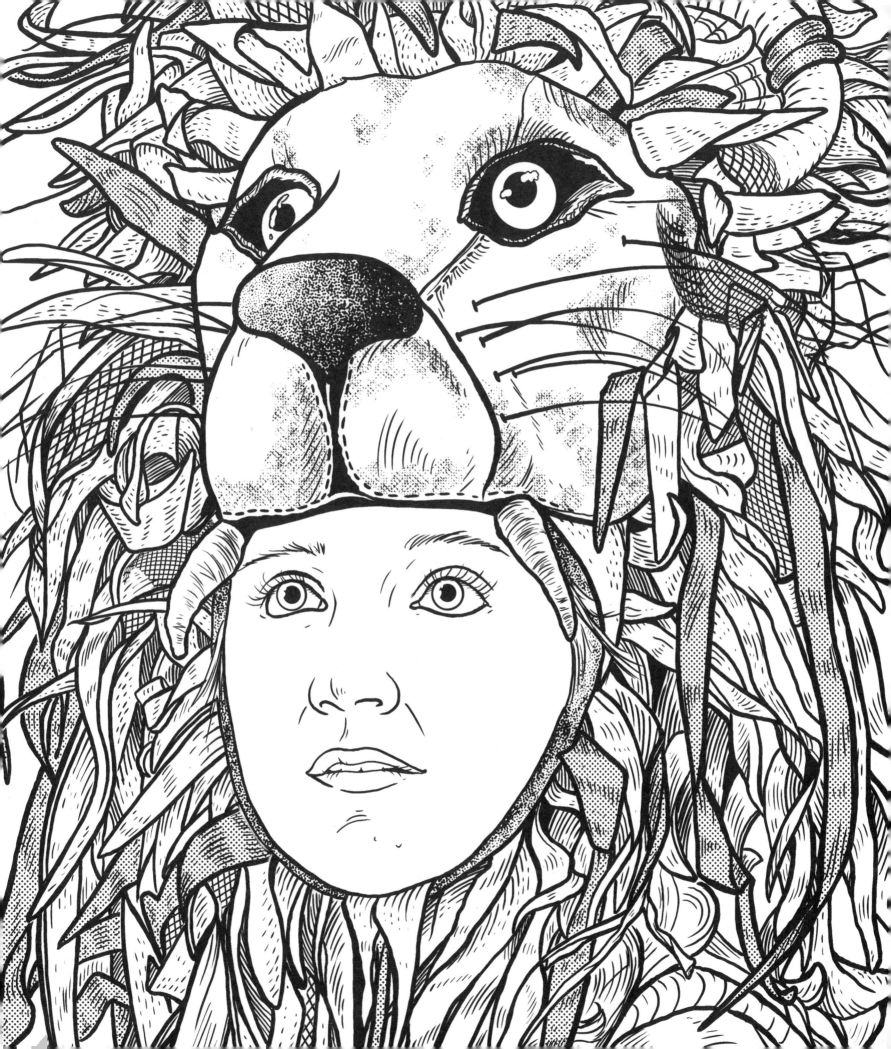

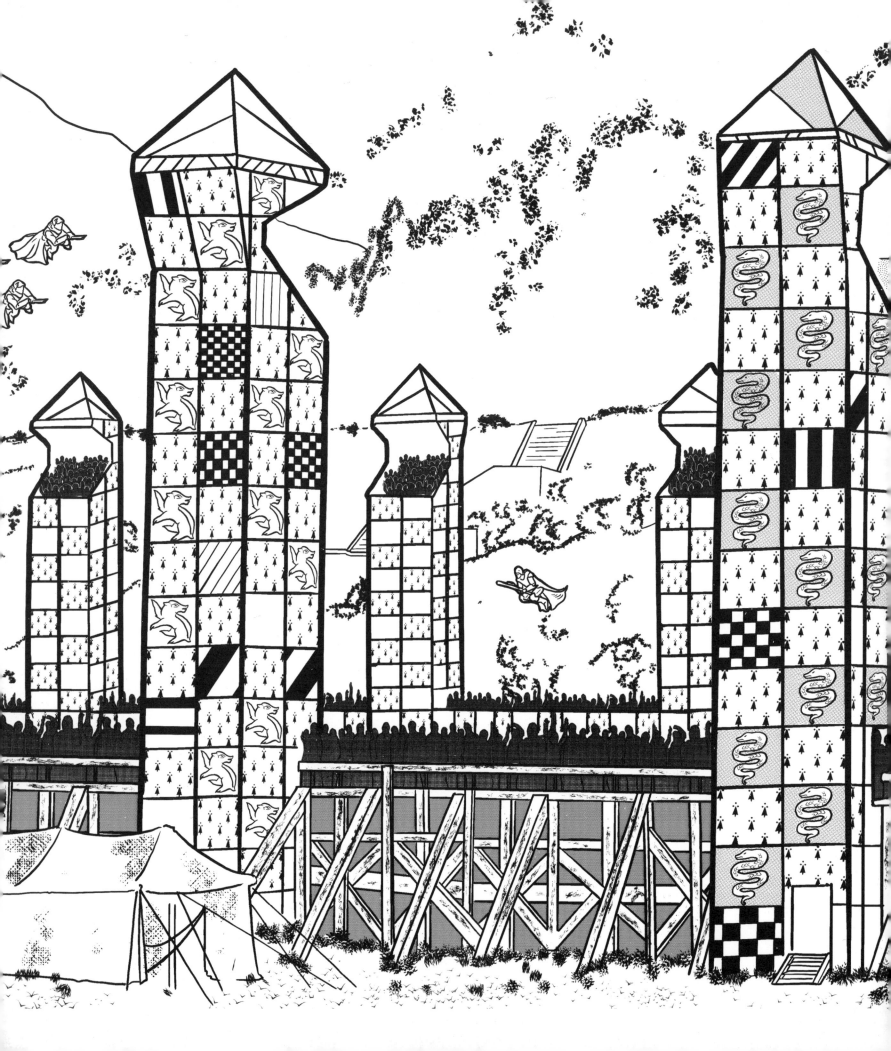

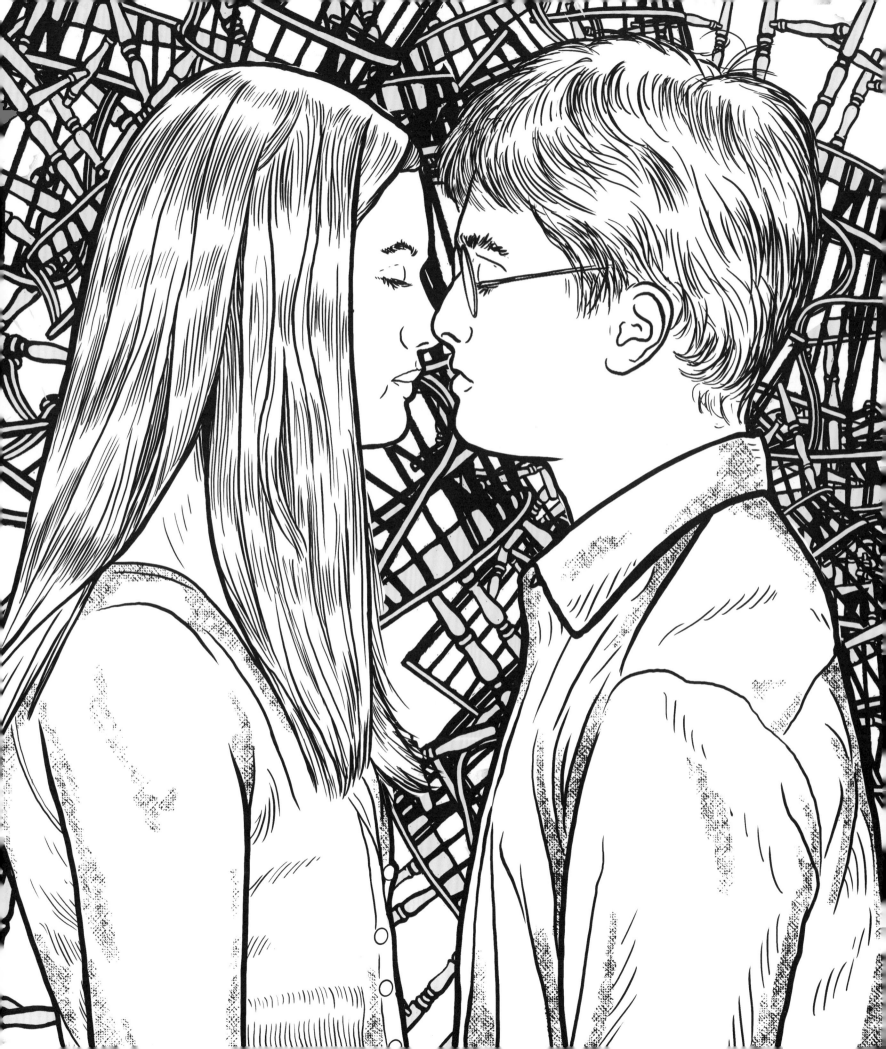

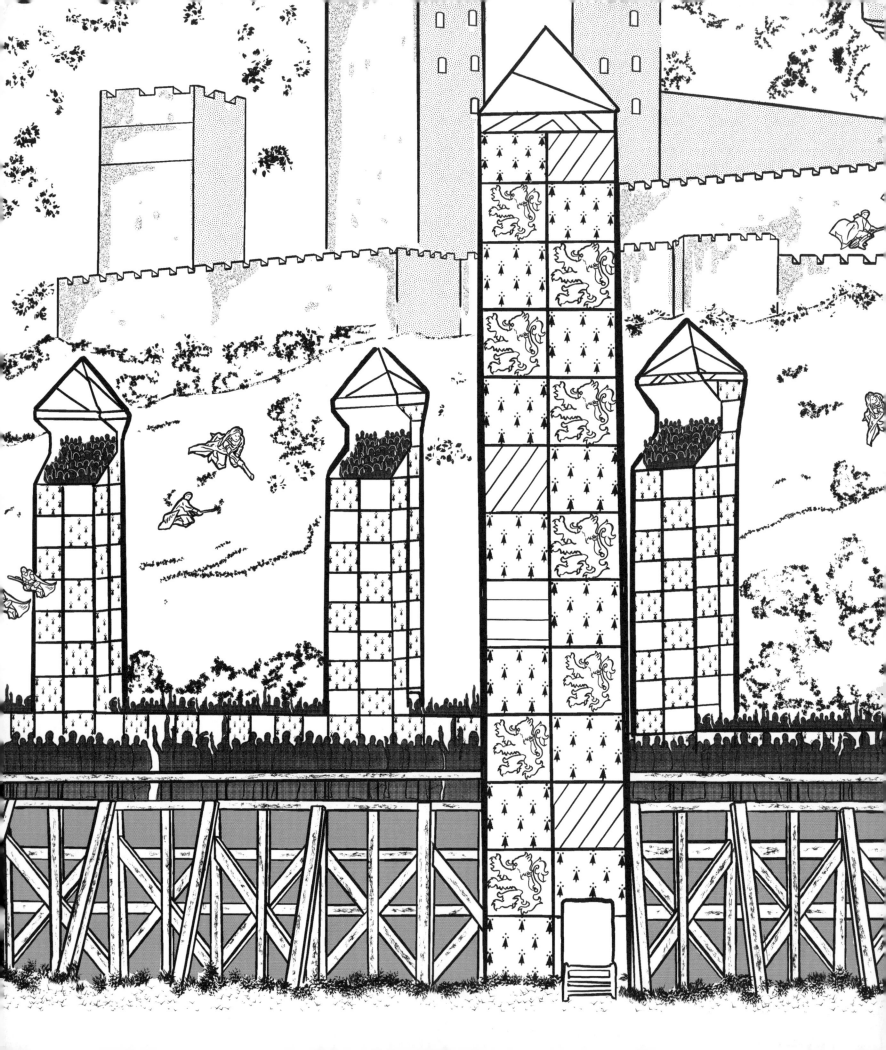

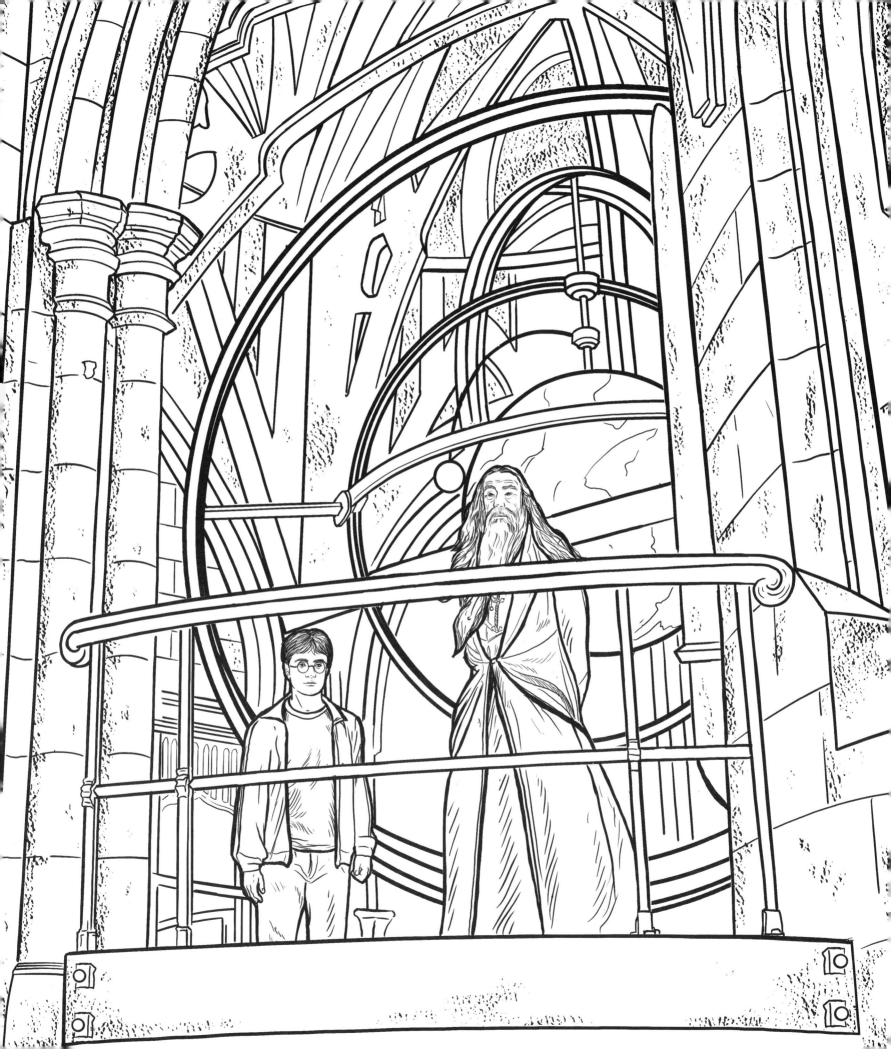

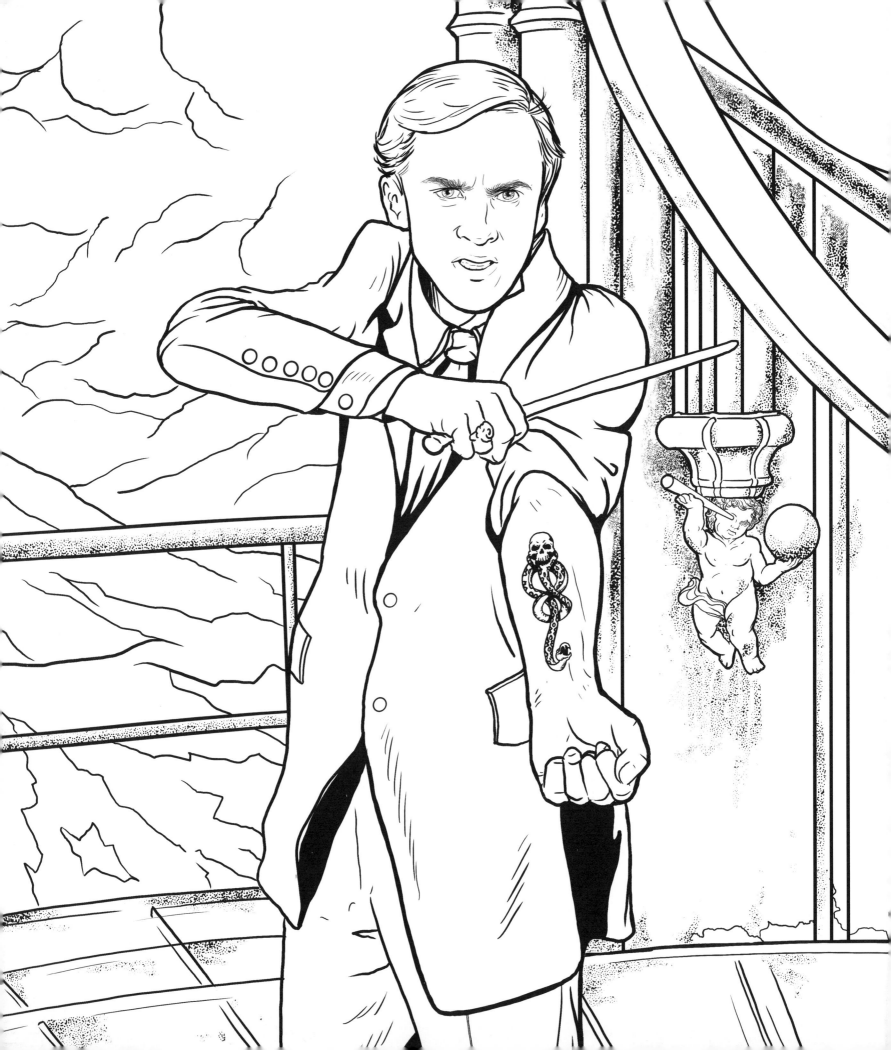

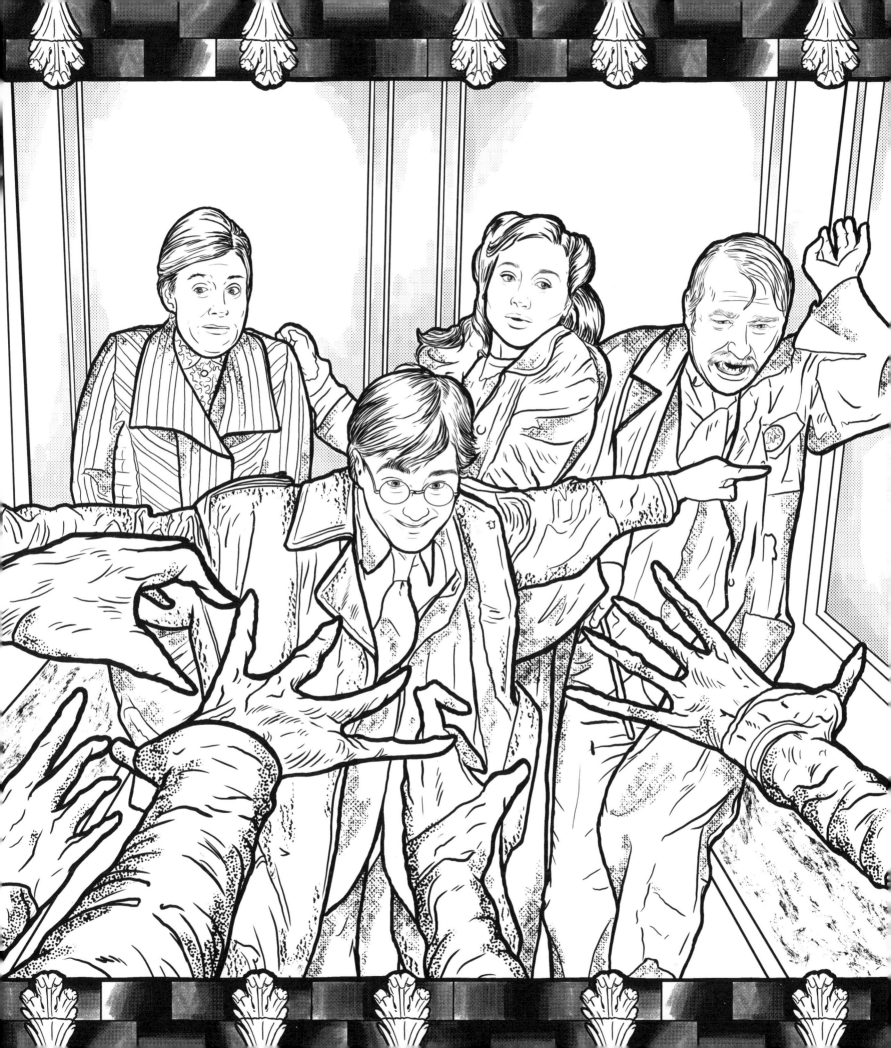

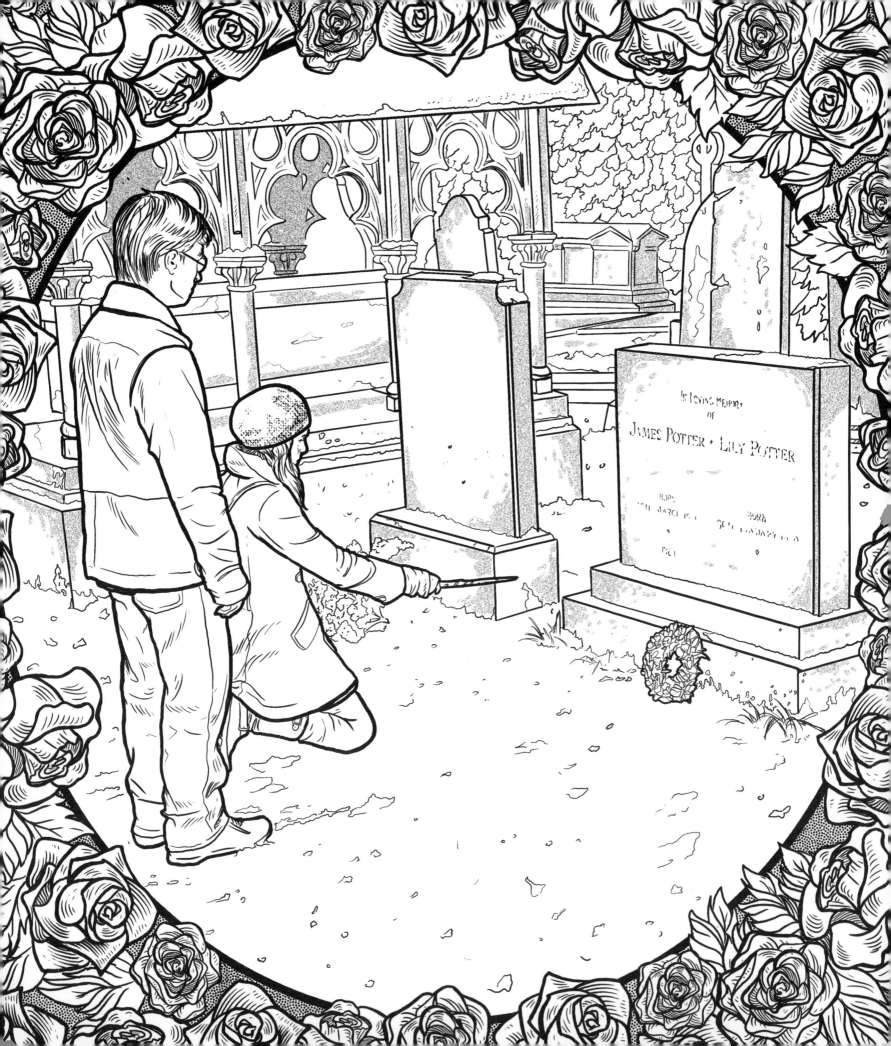

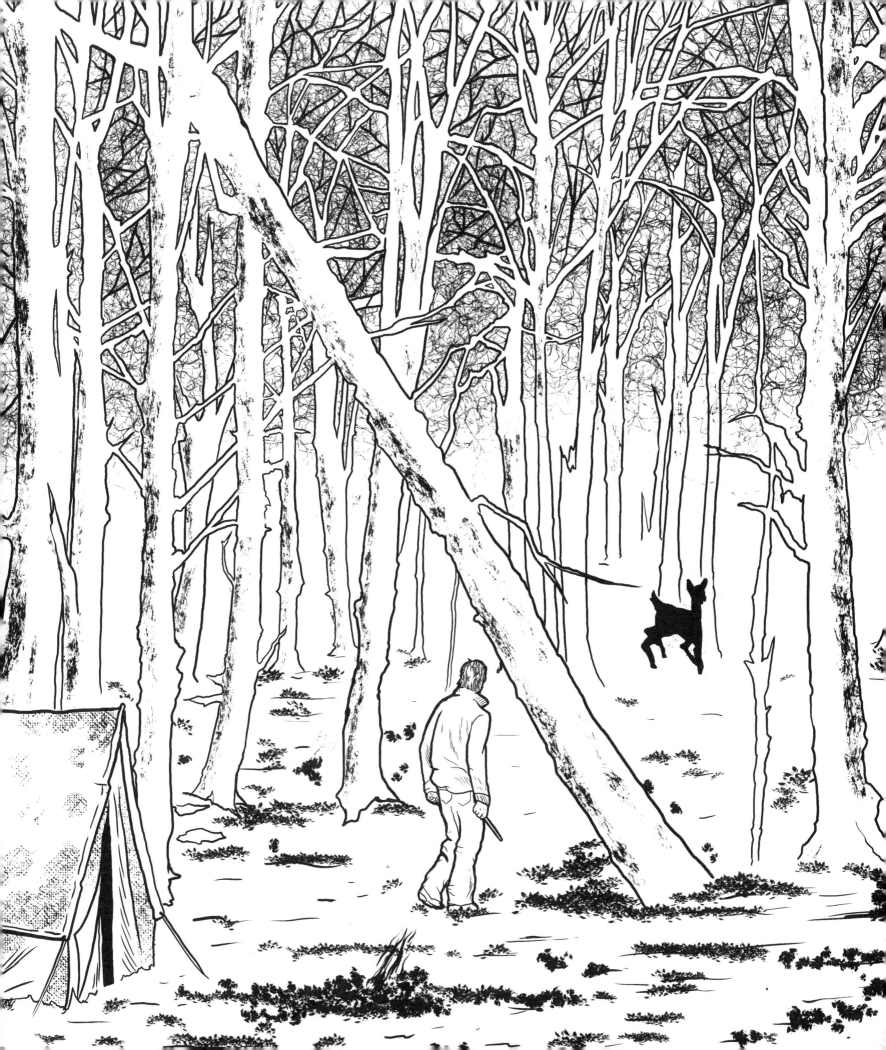

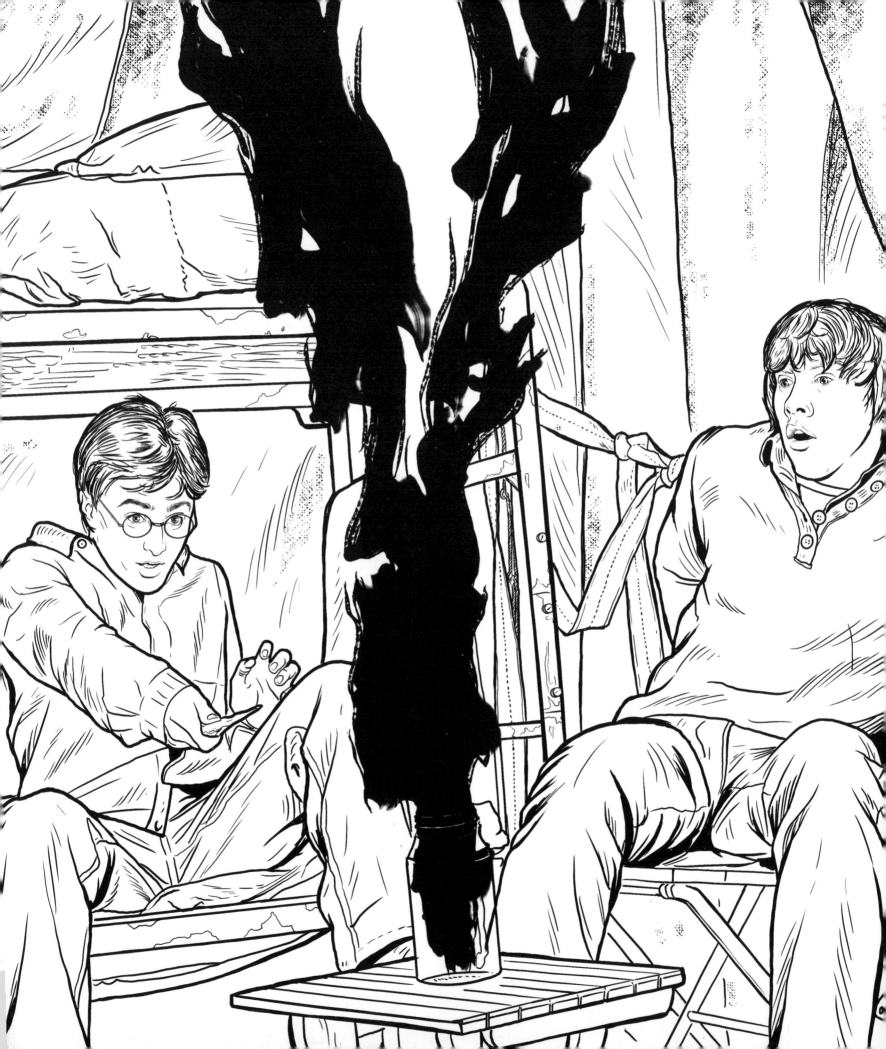

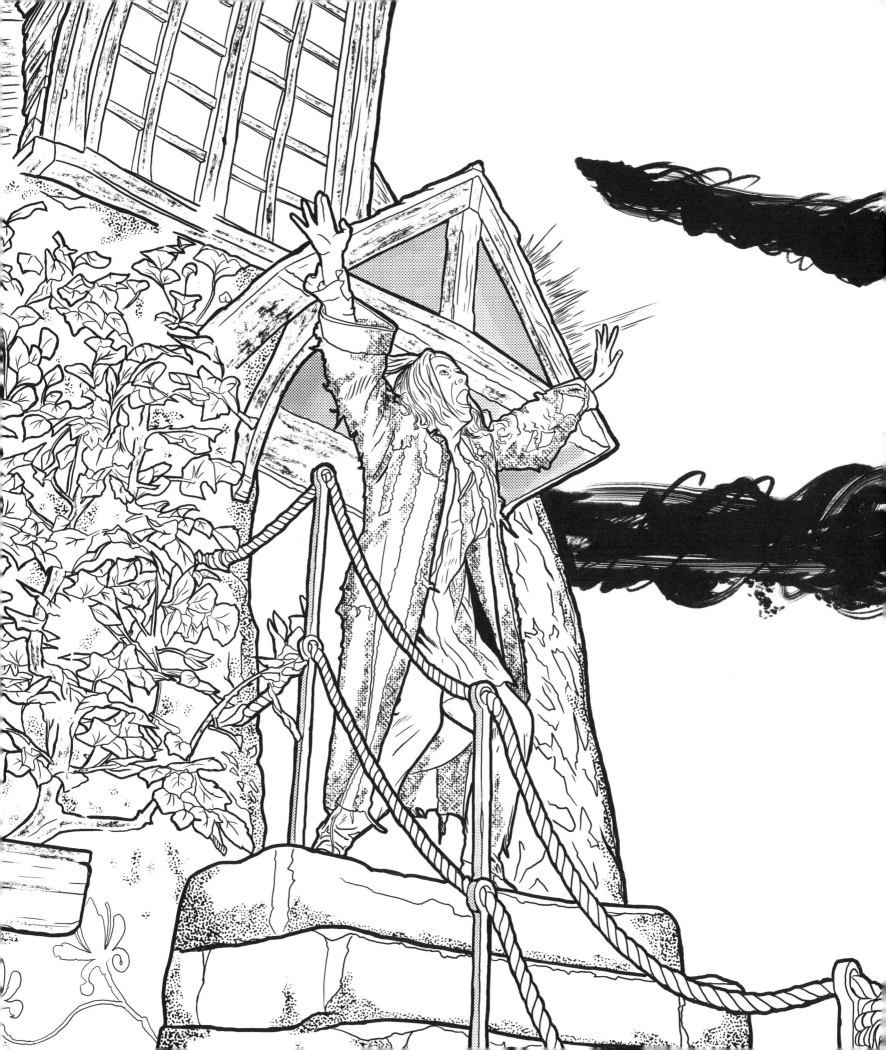

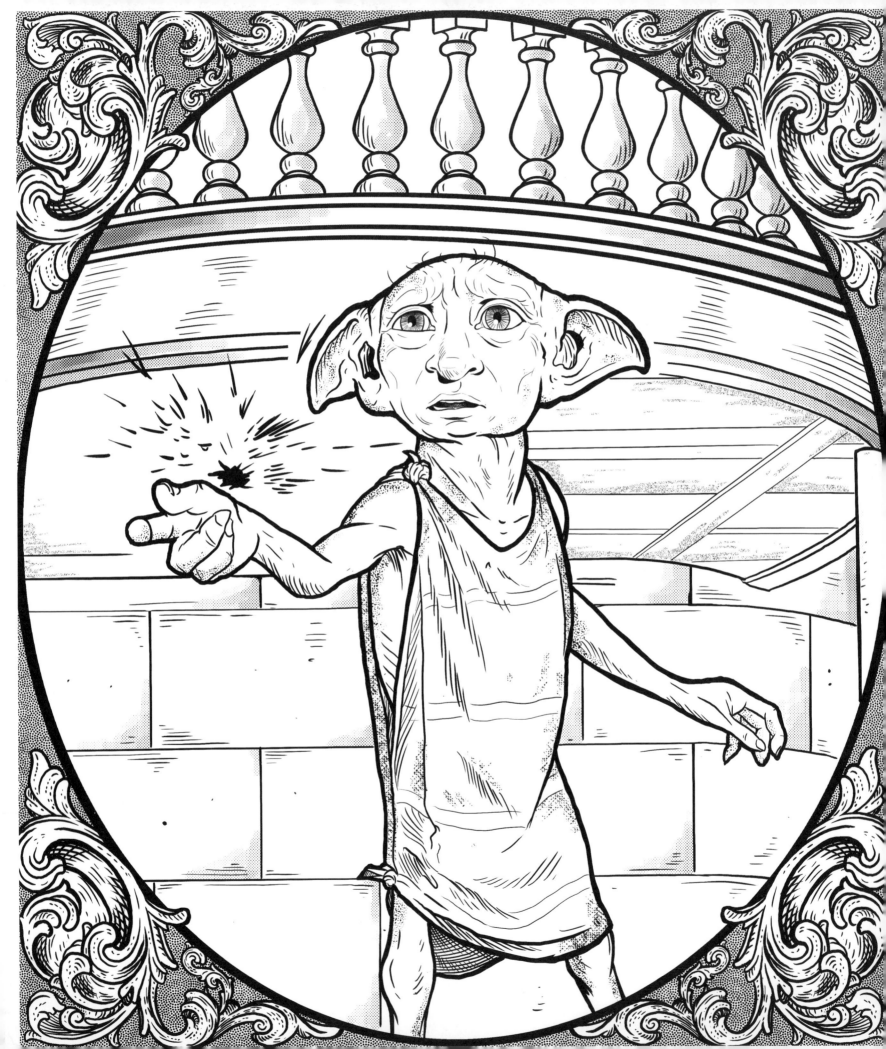

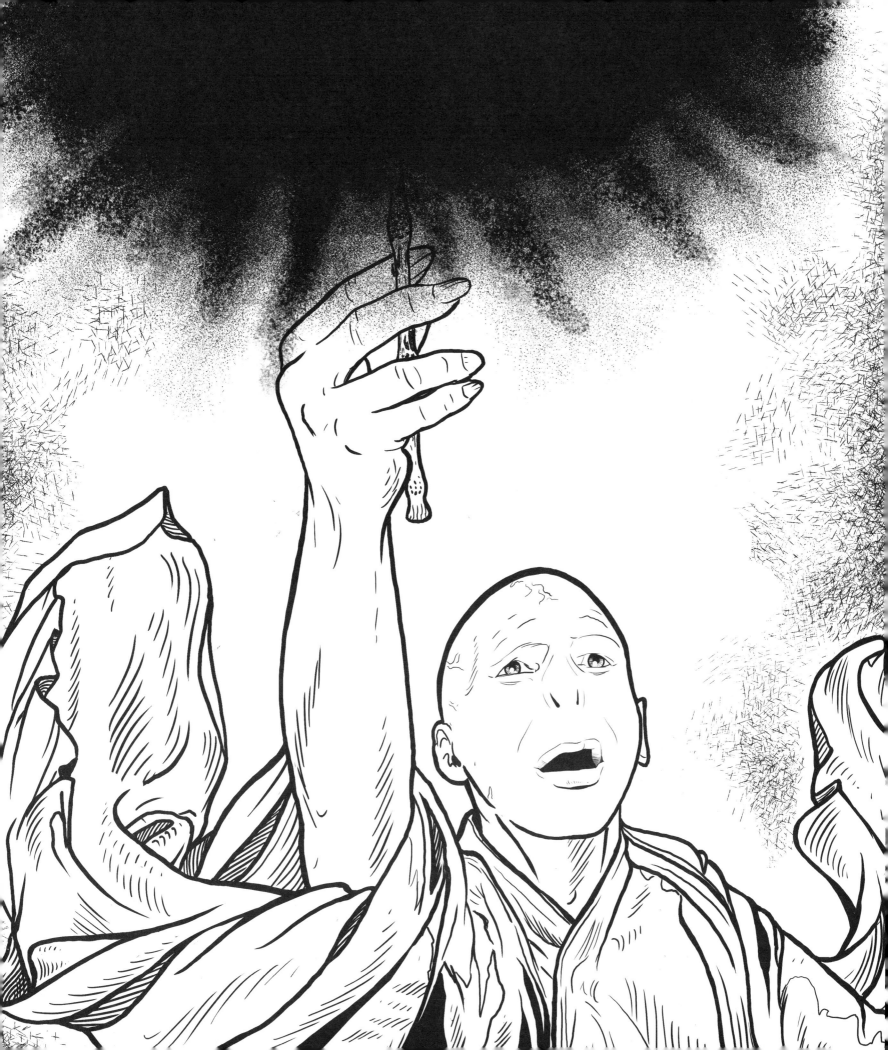

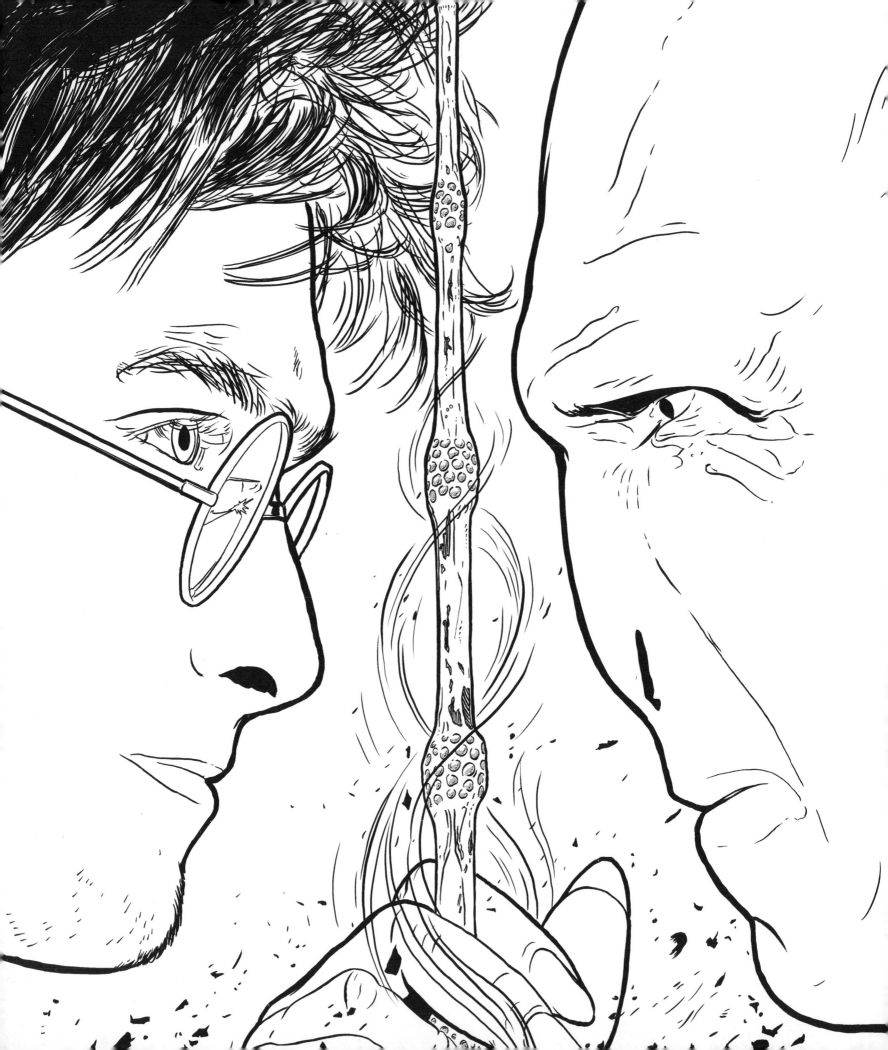

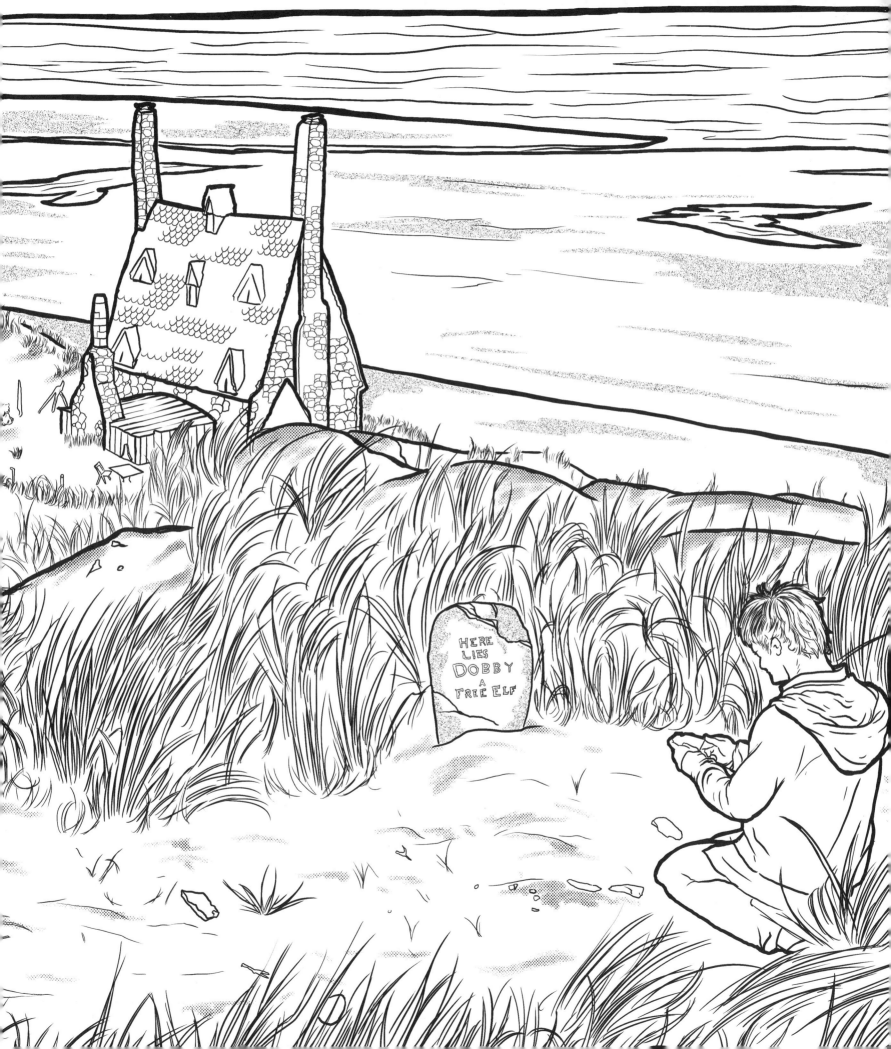

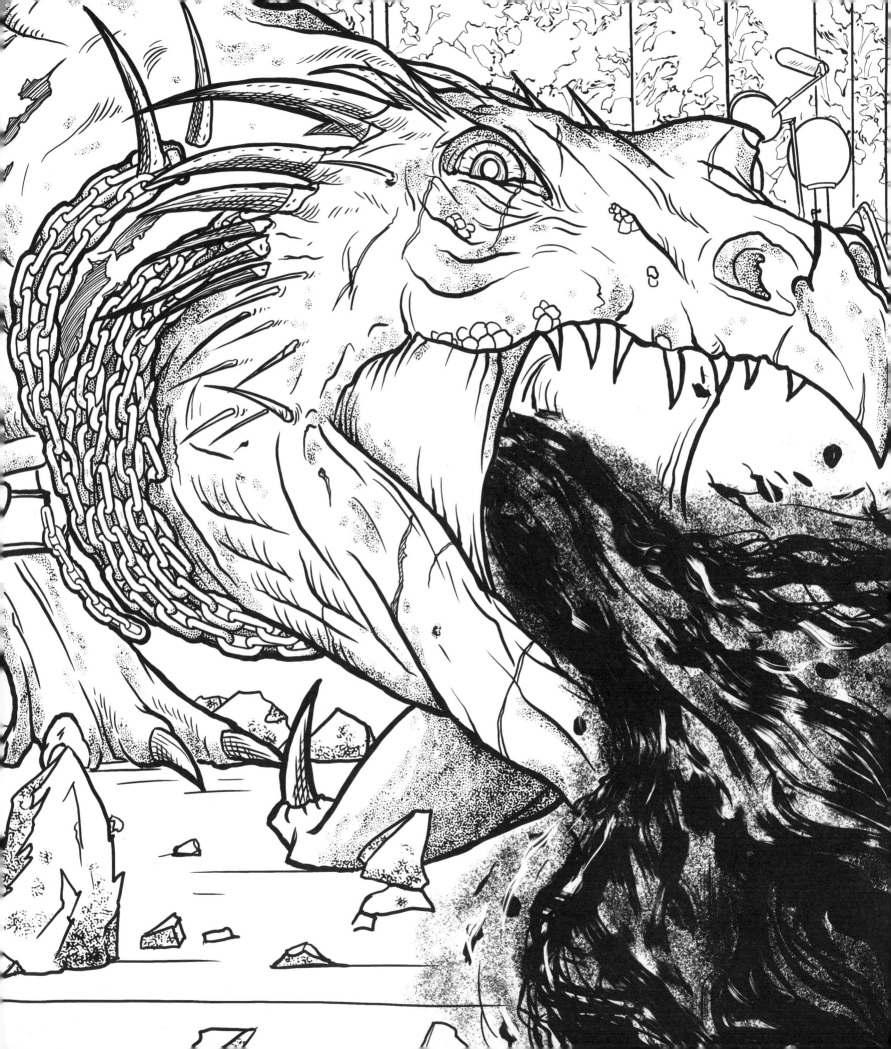

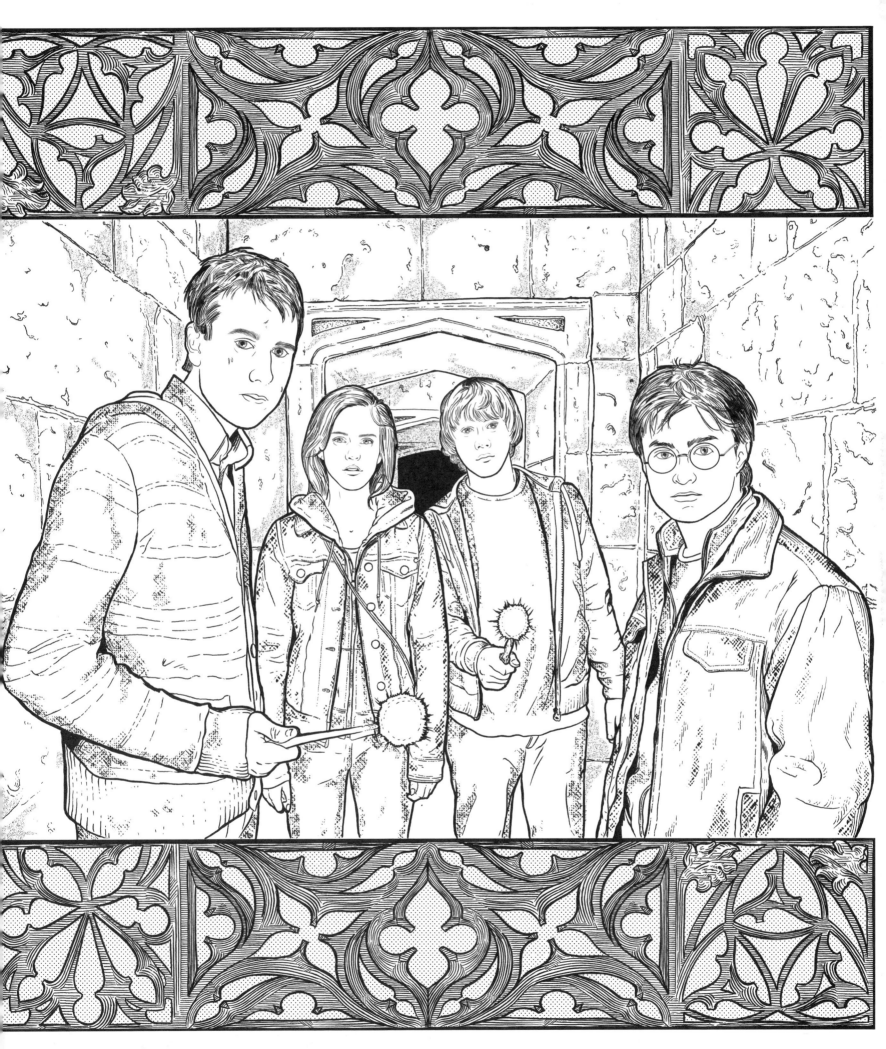

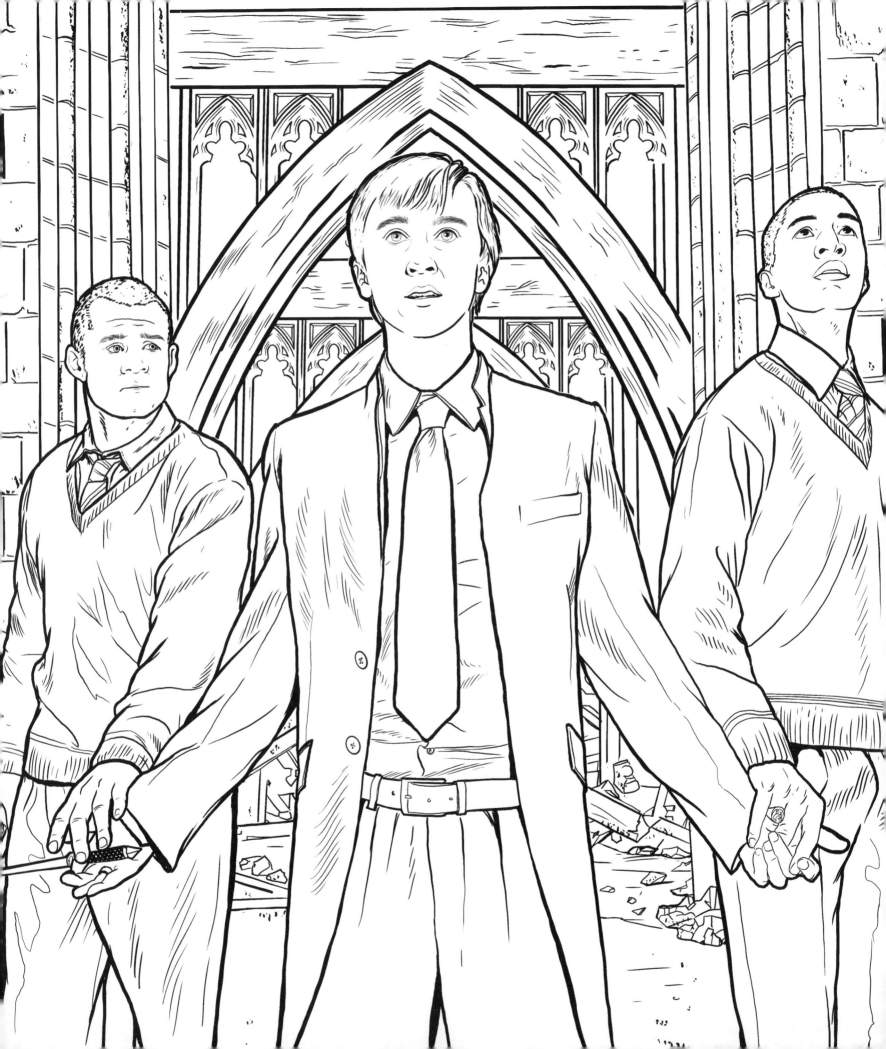

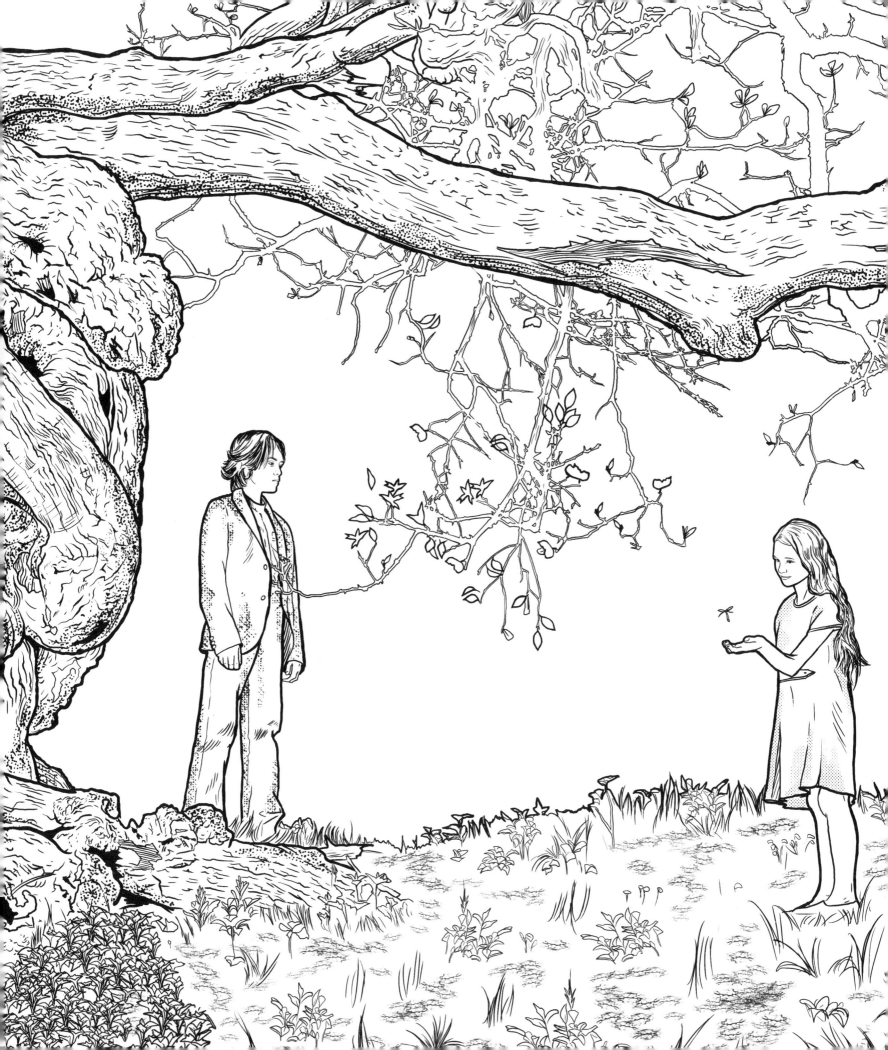

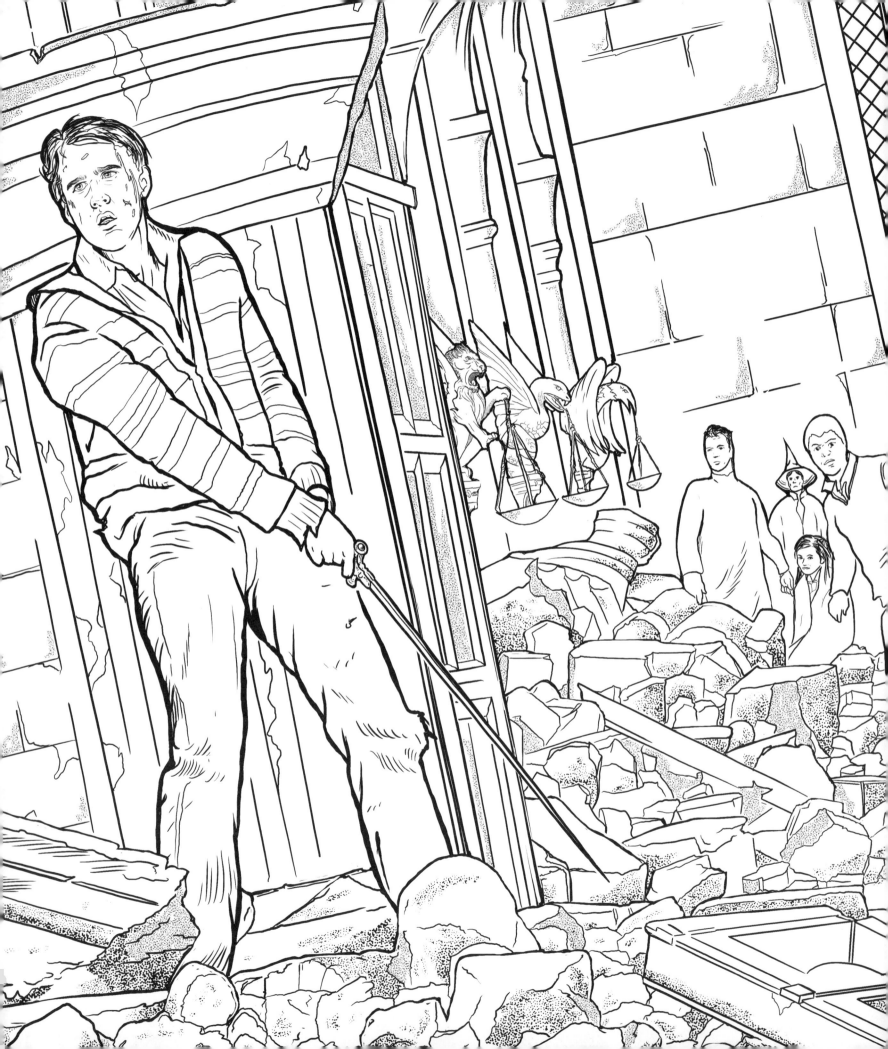

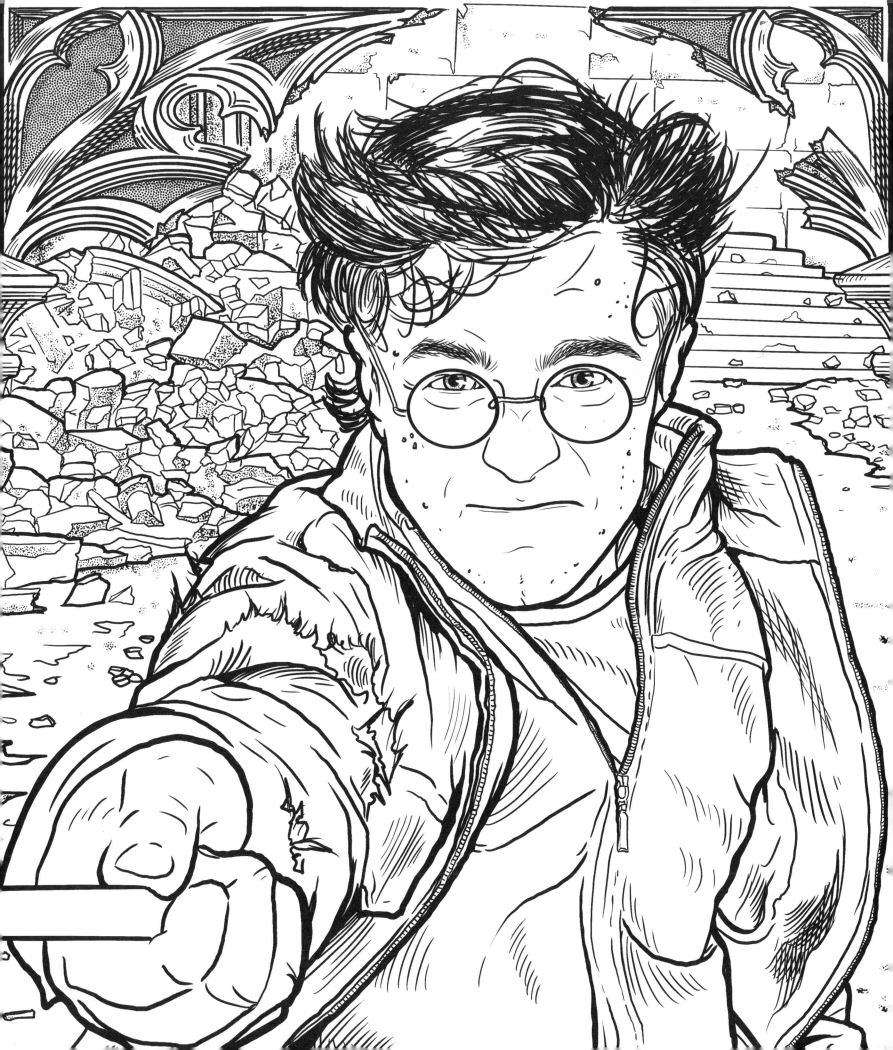

INSIGHT EDITIONS

PO Box 3088
San Rafael, CA 94912
www.insighteditions.com

Find us on Facebook: www.facebook.com/InsightEditions
Follow us on Twitter: @insighteditions

Library of Congress Cataloging-in-Publication Data available.

ISBN: 978-1-64722-196-6

Publisher: Raoul Goff
President: Kate Jerome
Associate Publisher: Vanessa Lopez
Creative Director: Chrissy Kwasnik
VP of Manufacturing: Alix Nicholaeff
Senior Editor: Greg Solano
Editorial Assistant: Hilary VandenBroek
Managing Editor: Lauren LePera
Senior Production Editor: Rachel Anderson
Senior Production Manager: Greg Steffen

Death Eater masks and Black Family tapestry illustrations by Frans Boukas.
Other illustrations by J.M. Dragunas with retouching by Robin F. Williams.

Insight Editions, in association with Roots of Peace, will plant two trees for each tree used in the manufacturing of this book. Roots of Peace is an internationally renowned humanitarian organization dedicated to eradicating land mines worldwide and converting war-torn lands into productive farms and wildlife habitats. Roots of Peace will plant two million fruit and nut trees in Afghanistan and provide farmers there with the skills and support necessary for sustainable land use.

Manufactured in China by Insight Editions

20 19 18 17 16 15 14 13 12 11